O9-ABH-696

Drawing Landscapes In Pencil

Nelson R. Kerr Jr.

Drawing Landscapes In Pencil

By Ferdinand Petrie

WATSON-GUPTILL PUBLICATIONS, NEW YORK

Paperback Edition
First Printing 1992

Copyright © 1979 by Watson-Guptill Publications

First published in 1979 by Watson-Guptill Publications,
a division of BPI Communications, Inc.,
1515 Broadway, New York, N.Y. 10036

Library of Congress Catalog Card Number: 79-15152

ISBN 0-8230-2645-0
ISBN 0-8230-2646-9 (pbk.)

All rights reserved. No part of this publication may be
reproduced or used in any form or by any means—graphic,
electronic, or mechanical, including photocopying, recording,
taping, or information storage and retrieval systems—without
written permission of the publisher.

Manufactured in U.S.A.

3 4 5 6 / 97 96 95 94 93

I dedicate this book to my family, whose unfailing help, encouragement, and support has made it possible for me to make my avocation my vocation.

Contents

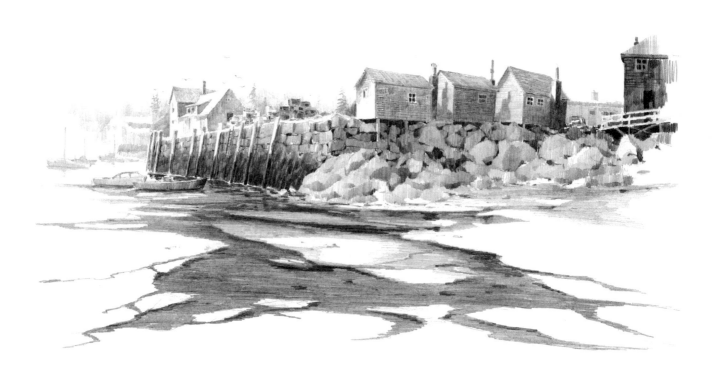

NEW ENGLAND MOTIF

I did not compose this drawing in the usual 2 x 3 proportions. I widen the view to see more of the harbor, similar to the effect of a wide-angle lens. I did very little changing or rearranging of the elements. The only change was in the foreground area. The sand and water lead the viewer's eye into the scene. After I lighly lay in the drawing with a 4H pencil, I start at the left side and finish each area as I work to the right side. The lights are drawn with a 2H pencil and the darks with a 2B pencil. The foreground is indicated last, using a 2H pencil. A drawing as wide as this is difficult to keep from becoming spotty. I use the stone wall and rocks to hold the elements together.

Introduction

Of all the mediums in art today, I feel the pencil is the most expressive, versatile, economical, and—most neglected. Even if you are not an artist and have never used paint or ink, I'm certain that you have used a pencil to either write or doodle. Artists are, of course, particularly familiar with the pencil for preliminary studies and sketches. Few regard it as a medium that can be used by itself.

With this book I would like to explore the possibilities a simple "lead" pencil offers the amateur and professional artist. It is not simply a means-to-an-end, but with knowledge, patience, and practice, the pencil can become a major end in itself.

Each medium the artist employs possesses special advantages and characteristics. Certainly, there are some disadvantages to pencil drawing, but with creative handling, the graphite pencil can produce more varied effects than any other black-and-white medium.

In this book I will be dealing with on-the-spot drawing. This may prove more difficult for some artists, but the spontaneity and freedom you get when drawing directly from nature are worth the problems encountered. The main difficulty, however, is the vast amount of material an outdoor subject presents to the artist. Painting on location may be overwhelming in subject matter, and therefore, some simplification of nature may be necessary. In the final chapter, I will show you how to do this by comparing a few of my drawings with photographs of exactly the same location.

I try not to cover material that can be found in other art books. Therefore, I stay away from important areas of perspective, form, and composition. Although it is impossible to write a book on drawing without including these areas, I do not make separate sections, but discuss perspective and composition where I feel it is necessary.

As you progress through the various stages of learning the art of pencil drawing, I hope you will gain the same enjoyment and respect for the graphite pencil that I have after many years of doodling.

Finally, since I am an artist and not a writer, I have based the book on the premise that one picture is worth a thousand words.

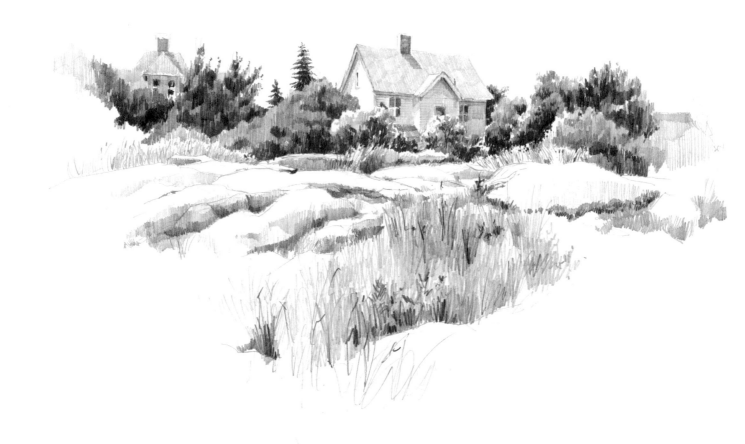

THE HEADLANDS

The variety of trees and bushes provide a pleasant setting for this house. By keeping the values in the trees dark, I can emphasize the light on the house. After the lay-in drawing with a 4H pencil, I render the trees with 2H and HB pencils. The large flat rocks in the foreground lead the viewer's eye to the house. The planning of the weeds and grass in this area is also extremely important. I render this area with a 2H pencil, leaving white areas to give an interesting vignette.

Materials

Today, a variety of pencils and papers are available. Experiment with the effects and textures you can get from different types of papers. Any type of paper will do when you are practicing lines, tonal values, and techniques. As you become more advanced and produce finished drawings, the best materials are an absolute necessity. Happily, one of the many advantages of pencil drawing is the inexpensiveness of the best materials. In this chapter I want to cover only the materials that I use when doing pencil drawings, such as, pencils, paper, backing boards, erasers, protective paper, and fixtures, as well as stools, sharpeners, and viewing mask.

Pencils

If you were to look in a catalog from one of the large art suppliers, you would find many types of pencils. There are carbon pencils, drawing pencils, ebony, flat sketching, layout, charcoal, China marking, etc. Each is used for a specific purpose and has its own characteristics. For example, the ebony pencils are very black and are good to use when reproducing your work. The flat sketching pencils contain square leads that become a chisel point when sharpened. Chisel point drawing is excellent for quick sketching and architectural renderings. Layout pencils were used for advertising layouts before markers were invented. They contain flat leads that are about ½" (1.3 cm) wide, and are used now mostly for quick sketching. Charcoal pencils are familiar to oil painters who use them for their initial drawings, and charcoal is also used for portrait drawings. China marking pencils are wax crayons used for working on slick surfaces, like photographs, which will not take a carbon pencil.

The type of pencil I use is the graphite or more commonly called the "lead" pencil. The graphite pencil comes in various degrees of hardness, designated by letters: "H" for the harder pencils and "B" for the softer ones. They also have numbers that indicate the degree of hardness or softness. For example, 6H is the hardest and 2H is the softest of the hard leads that I use. In the section on creating values in Chapter 2, you will see how the hardness of the lead enables you to create the values you will use in the drawing.

Pencils made by different manufacturers may differ in the degree of hardness or softness. Therefore, it is advisable to obtain sets of pencils made by the same company. I use hexagon-shaped pencils called "Castell 9000," which are made by the A. W. Faber Company. I use the following pencils: 6H, 4H, 2H, HB, 2B, 4B, and 6B. HB is the transition between the hard and soft leads. I have also used the Koh-I-Noor drawing pencil, the Venus pencil, and the Eagle "Turquoise"—all are of excellent quality (Figure 1).

Paper

Good quality paper comes in many weights, textures, sizes, and colors. Except for practice work, you should always use 100% rag content paper. This means that the paper is made of cotton fibers rather than wood pulp. Although you may not notice the difference while you are drawing, the wood pulp paper will eventually yellow and become brittle. Notice what happens to old newsprint pads.

Just as there are many excellent brands of pencils, there are also many excellent brands of paper. After experimenting with many different types, I now use 3-ply, smooth Bainbridge, or Strathmore Bristol Board. The chief difference between Bainbridge and Strathmore is the color; Strathmore is whiter while Bainbridge is more ochre. I use 9" x 12" (23 x 30.5 cm) or 11" x 14" (28 x 35.5 cm) Bristol Board pads, but when they are not available, I use the full sheet, which comes 22" x 30" (56 x 76.2 cm) and cut it in quarters. Bristol Board has an added advantage since you can use either side.

Perhaps more important than the manufacturer, weight, or color of the paper is the texture. With rougher textured papers, the lines become broken with small white spots, which is due to the hills and valleys of the paper. On the rough surface, the pencil marks the high areas and does not go into the depressions. You may find that the rougher textures are more interesting. However, for most of my drawings I prefer the smoother surfaces.

In addition to the regular papers, there are also

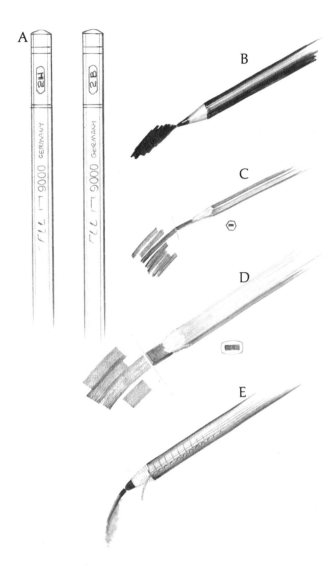

special surfaces. Scratch Board has a clay-coated surface that can be scratched out with a pin or razor blade; it is mostly used with ink. Ross Boards or Coquille Boards have a special surface that allows the artist to obtain a variety of tones between white and black, which can be reproduced as a linecut. The surface is partly in relief and partly depressed, much like a rough paper only in an even pattern, so that a tone is actually a series of tiny black areas separated by pure white. This board is used mostly in the commercial field. Figure 2 shows how the variety of paper surfaces affect the toned lines of the pencil.

Backing Boards

It is important to have a very hard surface so that the pencil will be responsive and sensitive to the paper. Even if I use a pad, I tear off each sheet and clip it on a 13″ x 18″ (33 x 46 cm) Masonite panel (Figure 3). A regular wood drawing board is heavier to carry and the wood grain affects the surface of the paper. The 13″ x 18″ (33 x 46 cm) size is small enough to be carried easily and large enough to be conveniently held on your lap while drawing outside.

Stools

At times on location, I have sat on anything available, which often becomes a problem. I now use a "Pack Stool," which is manufactured by Houtz and Barwick, Elizabeth City, North Carolina. However, any folding chair that is light to carry may be used. The Pack Stool is a lightweight metal with a canvas seat and pockets with zippers on each side, which hold my pencils, erasers, sharpeners, etc. It also has handles on the top, which makes it easy to carry (Figure 4).

Erasers

Although you are probably familiar with many types of erasers, there is only one that I recommend. It is the Conté Kneaded Eraser, which is a very soft rubber that can be pulled apart and molded or kneaded (hence the name) into any shape or size you may need (Figure 5).

Since any erasing on the paper will mar the surface and thus change the texture, I seldom use the eraser to change the drawing, but only to clean the lines where it may have become dirty. It is also possible, by carefully pressing the eraser against the paper, to lighten the value. Only *press*, however, never rub the surface (Figure 6).

Sharpeners

For the type of drawing I do, I use a sharpened point rather than a rounded or chisel point. Therefore, I

Figure 1. Pencils. *All manufacturers identify the grade pencil by numbers located in the same place (A). Be careful you don't sharpen the wrong end of the pencil and lose the grade number. The leads in the Ebony pencil (B) are round, soft, and very black. The flat sketching or chisel point pencil (C) has the same outside shape as other pencils, but the leads are rectangular. They can only be sharpened with a razor blade. The flat layout (D) is also called a carpenter's pencil. The leads are usually 3/16″ (.48 cm) or 5/16″ (.80 cm) wide and again must be sharpened with a razor blade. Large areas can be covered quickly, so it is often used for fast sketching. There are many makes and varieties of charcoal pencils (E). Some are similar to the regular lead pencil and can be sharpened with a sharpener. Others like this are paper-wrapped and have a string pull to sharpen the pencil.*

Figure 2. Paper. *(Right) The plate finish smooth Bristol Board (A) gives you very little texture in the tones that are drawn on the surface. It is very sensitive to the various grade pencils, which gives you the opportunity to create a more delicate drawing. Kid finish Bristol Board (B) has a very slight tooth or texture. This surface is better to use if you use only one pencil in your drawing. Cold-press Watercolor paper (C) is rougher than any of the Bristol Boards. This paper is good to use if you want to make color notation or add washes to the drawing. The Rough Watercolor paper (D) has the most tooth of any of the papers I have demonstrated. You can see how the tones and lines are broken with white paper. The only time I use this paper for drawing is when I want to make a large sketch. # 80 Bainbridge Illustration Board (E) has an excellent surface for drawing. It is a thin paper mounted on a hardboard backing, which makes it much thicker than the other drawing papers. This has an advantage when you want to make a very large drawing, since there is little chance of the board becoming torn or warped. I do not recommend the pebble mat board (F) for drawing. I include it because there may be a time when you want a special effect and this type of surface is just what you are looking for. The surface is very soft, however, and it is difficult to obtain a dark value. This is another rough surface mat board (G). Basically, it has the same effect as the pebbled board. You can get mat boards in any color or shade of gray.*

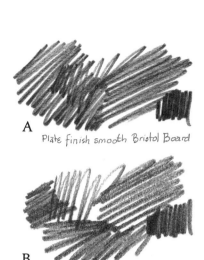

A
Plate finish smooth Bristol Board

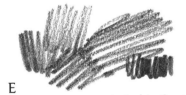

B
Kid finish smooth Bristol Board

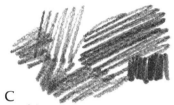

C
Cold press watercolor paper

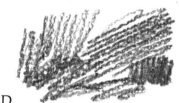

D
Rough watercolor paper

E
#80 Bainbridge Illustration Board

F
Pebble mat board

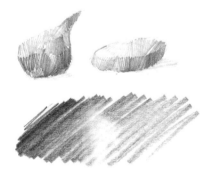

G
Rough surface mat board

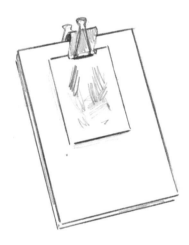
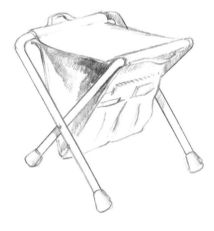

Figure 3. Backing Boards. *This 13" x 18" (33 x 46 cm) Masonite panel is easily carried, and just the right size to hold comfortably on your lap.*

Figure 4. Stools. *I have found the aluminum camp chairs are not strong enough. These tubular metal legs can hold quite a few pounds.*

Figure 5. Erasers. *A kneaded eraser can be pulled and stretched in any desired shape. The main advantage is that it will not leave any crumbs on the drawing.*

Figure 6. Using the Eraser. *It is easier to lighten the darker tones because of the softer pencil. Use the eraser as little as possible; don't become dependent upon it.*

Figure 7. Sharpeners. *Actually, you can use any type of sharpener you like. I would use my electric sharpener if I could figure out how to plug it in when I'm out in the field.*

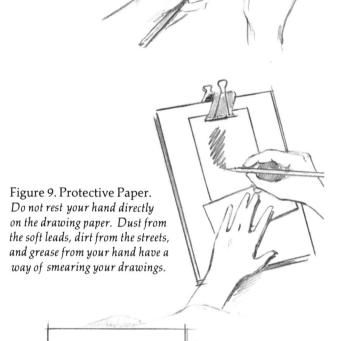

Figure 8. Razor Blades. *When sharpening a chisel edge pencil with a razor blade, be sure to always keep the sharp edge of the razor away from you.*

Figure 9. Protective Paper. *Do not rest your hand directly on the drawing paper. Dust from the soft leads, dirt from the streets, and grease from your hand have a way of smearing your drawings.*

Figure 10. Viewing Mask. *A piece of mat board with a 3″ x 5″ (8 x 13 cm) hole acts as an excellent view finder for selecting your subjects.*

use a regular pencil sharpener with its own receptacle to hold the shavings. I often sketch in museums, homes, or other buildings where pencil shavings would not be welcomed on the floor. Remember, when you paint or draw outside, you are generally a guest on someone's property, so always leave the area the way you found it with no evidence that you were there (Figure 7).

In chisel point drawing you will have to sharpen the pencil with a razor blade, since the leads are square. To do this, be sure to use a single-edged razor blade. If you are right-handed, hold the pencil in your left hand, the razor in your right hand, and gently push the blade against the wood of the pencil, using your left thumb (Figure 8). Be sure to have the razor blade always facing away from you. Turn the pencil with your left hand until you have about ⅛″ (.32 cm) of lead showing. Be careful not to nick the lead since this will make it weak and more apt to break as you are drawing. Once the lead is exposed you can use a sandpaper block to achieve the chisel point you desire. Keep the lead edges sharp—this will give a nice crisp look to your drawing.

Protective Paper
Pencil drawing, like charcoal, smudges when your hand brushes against its surface. I always use a small paper under my drawing hand (many times it's another artist's brochure—they are excellent), so that there is a separation between the paper I am drawing on and my hand (Figure 9). Also, touch the paper as little as possible, since your fingers may contain grease or oil, which will mar the surface.

Fixatives
On a smooth board fixatives will leave spray marks or blotches. Also, if too much fixative is sprayed on one area, it will have more shine than the other areas. Therefore, I never use a fixative to protect my drawings. If I am not going to frame them immediately, I will put a clear acetate over the mat to protect the drawing. If you prefer to fix your work, I would recommend a spray fixative with a matte surface.

Viewing Mask
I use a viewing mask to reduce the amount of area I see with my eye. It is a piece of mat board about 7″ x 9″ (18 x 23 cm) with a rectangular hole cut in the center approximately 3″ x 5″ (8 x 13 cm) which acts similar to a view finder in a camera. I have often noticed how the rearview mirror on the side of my car will give me a beautiful composition. The main idea is to cut down your viewing area . . . don't see too much (Figure 10).

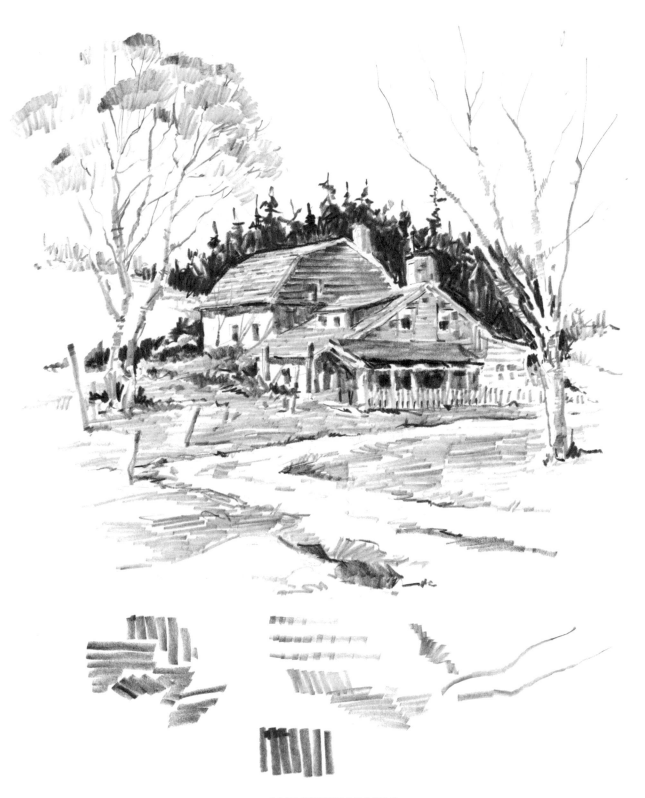

HAMILTON FARM

In this drawing I use 2H, HB, and 2B Microtomic Chisel Point pencils made by Eberhard-Faber. With chisel point drawing, I plan my values and vignette exactly the same way I do when I make a sharp point drawing. Notice the crisp individual strokes that are typical of this drawing method. The most important fact in chisel point drawing is that the point must be kept sharp with a sandpaper block.

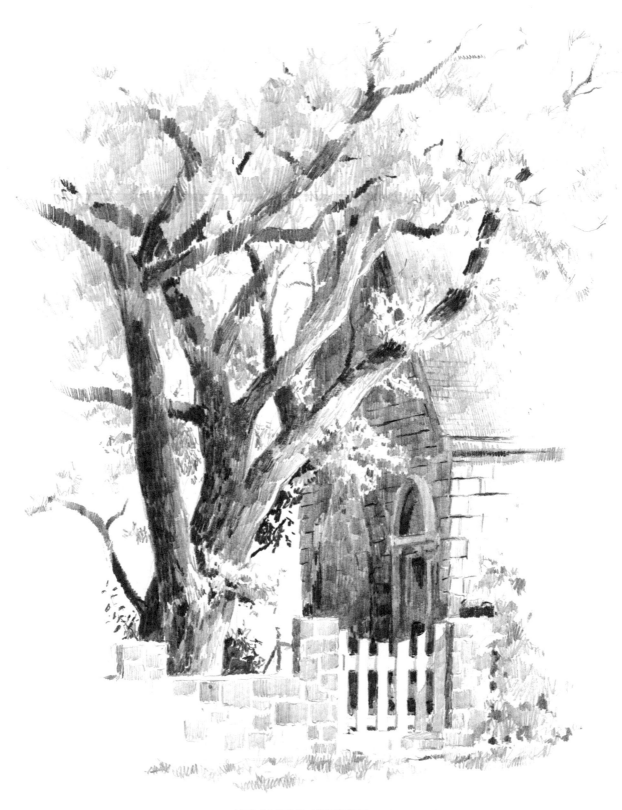

ATLANTIC AVENUE

In this drawing, I include the gate and a portion of the house in order to give a setting for the tree, which is the most important part of the drawing. I pay particular attention to the lay-in drawing. It is necessary that I know exactly how the main branches weave in and out, and once I establish this, I render the tree with an HB pencil. In most cases, I keep the darker branches behind the lighter branches. I render the house with a 2H pencil and spot the dark areas with a 2B pencil.

CHAPTER TWO

Getting Started

Like the athlete who has acquired the best equipment and is ready for the challenge of competition, you are now ready to use the materials. However, before the athlete starts the game, he generally must "loosen up" to relieve the tension. Some athletes go through months of preparation, while others only a few hours. The same is true for the artist. You must loosen up before you meet the challenge of that white paper.

In this chapter I would first like to show you how to hold the pencil and how to loosen up. Then I show creating values, forms, and textures with the pencil, smudging for tones, and seeing the landscape as values and vignettes.

Holding the Pencil
When you start to draw, hold the pencil two different ways. The first is the normal way you would hold a pencil to write a letter. The second way is how you normally hold a brush for oil painting—between the thumb and first finger, with the pencil under the palm of the hand (Figure 11). Notice in the illustration how the little finger acts as a guide for your hand. It is easier to control the amount of pressure on the pencil when you let the nail of your little finger glide over the paper. In both methods of holding the pencil, do not grip it too tightly.

Loosening-up Exercises
Using an HB pencil, loosen up with a series of lines, circles, and ovals. Do not spend a lot of time with each, but do them very quickly (Figure 12). Try to achieve complete control of the pencil by using the whole arm instead of just the fingers. You will eventually obtain even circles, lines, and tones.

In making the beginning circle exercise, start with your pencil above the paper and your little finger on the paper. Make a circular motion with your hand. As you get the rhythm of the circle, lower the pencil to the paper. Repeat the same procedure with each circle, doing each very quickly. Fill a page of these circles and then vary the pressure. Start the circle by pressing heavily on the paper, and finish the circle with light pressure. After you have gotten

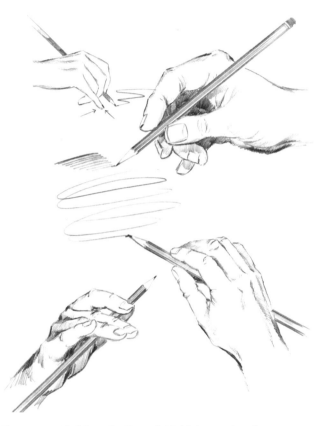

Figure 11. Holding the Pencil. *Hold the pencil in the most comfortable manner for you. I have suggested these two methods because they are most natural for me.*

the rhythm and the circles are clean, reverse this procedure.

Next, do a series of straight lines. By again varying the direction and the pressure, notice the various effects you can obtain.

Creating Values
The placement of values is of prime importance in the composition of a picture. By using one pencil, it is possible to create all the values in a drawing. To do this, it is necessary to use a pencil that will make a dark value. I use a 2B and by varying the pressure

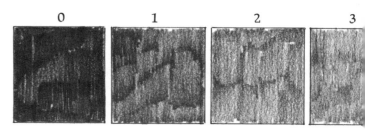

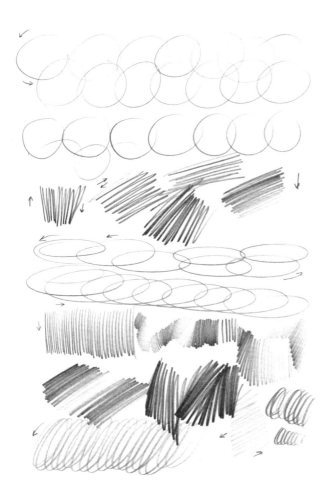

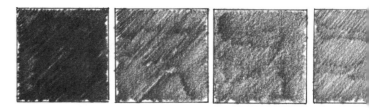

Figure 13. Creating Values. *To create all the values between white and black, I use the following pencils: 6B pencil for 0 and 1; 4 B for values 2 and 3; 2B for the 4th value; HB for the 5th value; 2H for the 6th value; 4H for values 7 and 8; and 6H for the 9th value. The 10th value is the white paper.*

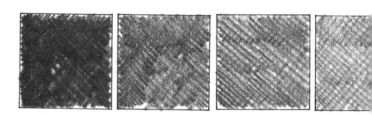

This chart is created by using the same pencils as above for the values; however, the strokes are drawn on a slant. Try all different directions for the strokes, but keep the values the same.

I use only a 2B pencil for this chart. The values were made by cross-hatching and varying the pressure on the paper.

Figure 12. Loosening-up Exercises. *Try these exercises with different grade pencils. Notice the dark values you can obtain with the B pencils. Do these quickly, using your arm, not just the fingers.*

on the paper, you can render all values between white and black.

Another way of creating values is by using different grade pencils for different values. I create all the values between white and black with seven pencils as follows:

0	1	2	3	4	5	6	7	8	9	10
6B		4B		2B	HB	2H	4H		6H	

Before you start any drawing, make a chart of all ten values using the pencils I have indicated. Make each square 1″ (2.5 cm) and create the tones with vertical lines, horizontal lines, and cross-hatching. Do each value as carefully and accurately as you can (Figure 13).

There are two other exercises you should do in order to understand values and how to achieve

them: 1. Using the seven pencils of grades 6B, 2B, HB, 2H, 4H, and 6H, make a chart of a graded tone from value 0 (black) to 10 (white). Be sure as you change pencils that there is a gradual blending of the tones. Notice how you can create a very smooth blending from one value to the next by simply changing the pencils. 2. The second exercise is the same graded value chart you did (above) with seven pencils, but now you will only use one pencil. When doing this, it is necessary to use a pencil that will make a dark enough tone to create a solid black. By using a 4B pencil you are able to create all the values from 0 to 9 by changing the pressure. When you grade the values with one pencil, the texture of the paper becomes an important element, since with less pressure the roughness of the paper becomes more apparent (Figure 14).

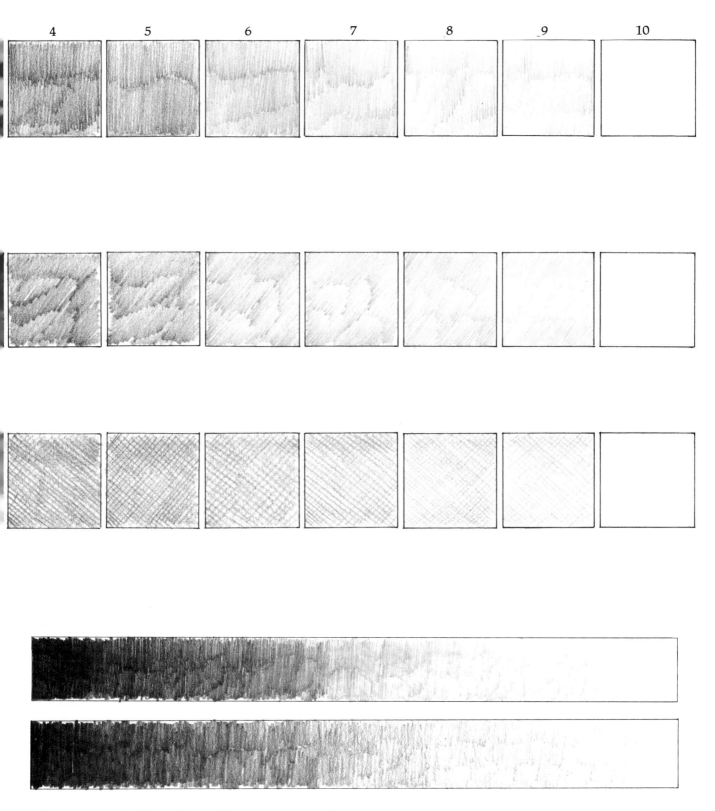

Figure 14. Graded Value Chart. *This chart is a graded value scale from 0 to 10. The same pencils were used as in Figure 13 (above), but blended together to create an even graded tone. This was drawn with a 4B pencil using only vertical strokes. As the tones become lighter, I have put less pressure on the paper. Notice in this plate how the texture of the paper becomes apparent with the lighter tones.*

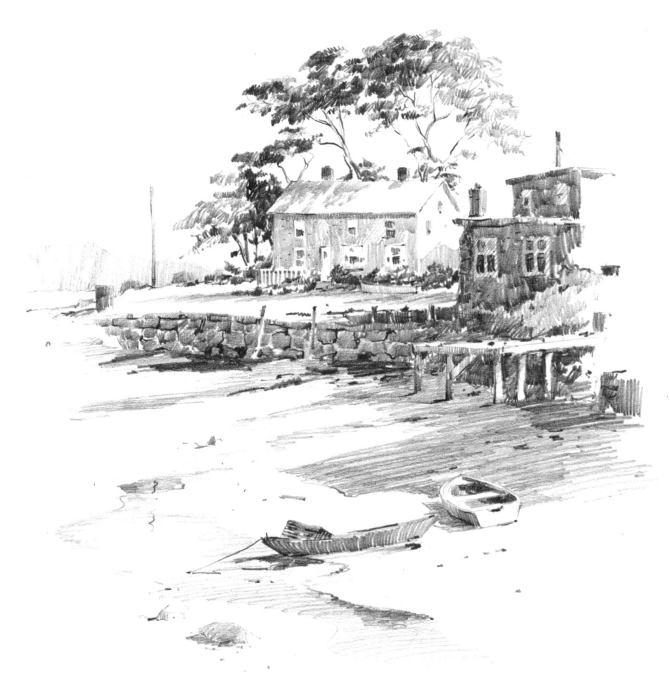

BACK HARBOR

In this drawing I use only one pencil, a 2B, since it gives me the darks I need. A slight grain of the paper shows where I lighten the value by using less pressure. You can see this most noticeably in the foreground area. I use horizontal strokes in the foreground to make the area appear flat, and to direct the viewer's eye from left to right. Although the finished drawing looks the same as when you use several grade pencils, it is more difficult to control the values.

Creating Forms

One of the most difficult problems of drawing is indicating a three-dimensional form on a flat piece of paper. The best demonstration of producing three-dimensions is with a drawing of a cube that has height, width, and depth. If there is a flat overall light on a cube, it is difficult to see the light side, the middle tone side, and the shadow side. When a single light is directed on the cube you will be able to see the height, width, and depth. Each surface of the cube will have a value, and the difference be-tween these values will reflect the amount of light. For example, if the lightest side of the cube is a 9th value and shadow side is a 1st value, there is a stronger light effect than if the difference were a 7th value for the light and a 5th value for the shadow.

I now indicate these values to create the form, with the same methods that I used to make the value charts. I can either use one pencil and change the pressure to make the values, or I can use all seven grade pencils (Figure 15).

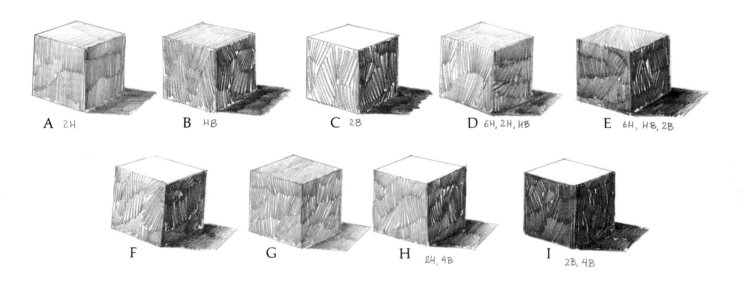

A 2H B HB C 2B D 6H, 2H, HB E 6H, HB, 2B

F G H 2H, 4B I 2B, 4B

Figure 15. Rendering Tones to Create Forms. *With a 2H pencil (A), I indicate the light value, the middle value, and the dark value. It is difficult to achieve a strong light effect since the darkest tone I can obtain with a 2H pencil is the 6th value. When I use an HB pencil (B) I can achieve a much stronger light on the cube, since the HB pencil can make a 4th or 5th value. However, by reducing the pressure on the pencil I create more texture in the middle tone side. A stronger light effect is obtained with a 2B pencil (C) because the shadow side now becomes a 3rd value. As the pencils are softer, the texture in the paper becomes more noticeable. By using a 6H pencil for the lightest tone, a 2H for the middle tone, and an HB for the shadow (D), I have more control in creating the values. The value relationship between the middle tone and the shadow is only one value difference, which gives a very weak light effect. A stronger light is obtained by using an HB pencil for the middle tone and a 2B for the darks (E). There is still only a one value difference between these two sides, which does not enhance the form. In (F) I leave the lightest side white. By doing so, I have made that side as light as possible. In effect, this is the same as using a darker value in the shadows. By keeping the values on each side close together (G), you can achieve the effect of a very dim light. In a landscape, for example, this could give you a very hazy or foggy atmosphere. The value relationship in this cube is 9, 8, 6. I achieve the strongest contrast in values (H) by keeping the light side white, the middle tone a 6th value with a 2H pencil, and the dark side a 3rd value by using a 4B pencil. In most drawings I try to keep this relationship of values. In order to create the strongest effect of light possible (I), I leave the light side white and the middle tone a 4th value with a 2B pencil and the darks a 3rd value with a 4B pencil. This has the effect of a strong spotlight on a subject.*

Fundamental Strokes

There are a few basic strokes that when practiced and applied will be helpful when drawing on location. I did not indicate all strokes possible since you will discover many on your own as you practice and sketch.

I have used three pencils, 2H, HB, and 2B, but I would encourage you to try each exercise with different grade pencils. Keep in mind that strokes of all kinds and combinations should be drawn without trying to create a picture, although some of the exercises may take on the appearance of actual objects (Figure 16).

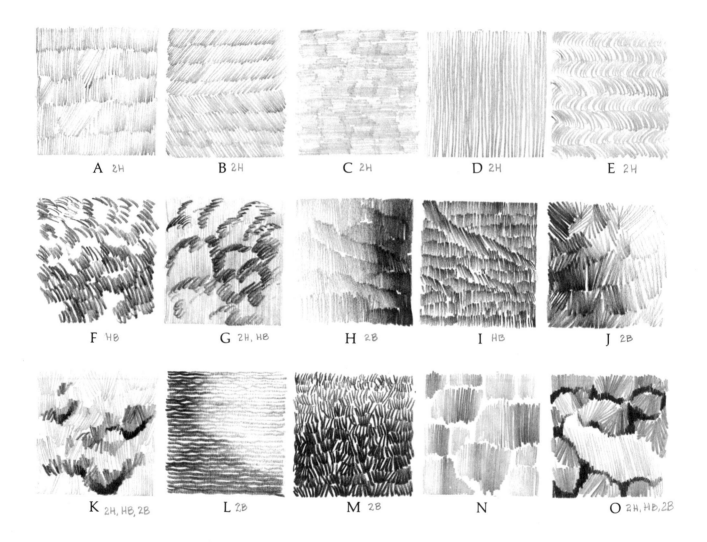

Figure 16. Fundamental Strokes. *Some of the infinite number of strokes and patterns that are created by using the 2H, HB, and 2B pencils: Short vertical strokes (A) with 2H pencil varying the direction, even pressure. Short strokes (B) at an angle, even pressure, 2H pencil. Short horizontal strokes (C), even pressure, overlapping, 2H pencil. Long vertical strokes (D), irregular lines, even pressure, 2 H pencil. Short, curved lines (E) in different directions, 2H pencil. Short, curved strokes (F) in one direction, leaving white spaces, with HB pencil. Short, curved strokes (G) with HB pencil. Vertical background with 2H pencil, using vertical strokes. Short, vertical strokes (H) with 2B pencil, varying the pressure and direction. Short, vertical strokes (I), even pressure, vary direction with HB pencil. Short, angle strokes (J), varying pressure and direction, with 2B pencil. Combination of 2H, HB, and 2B pencils to vary short angular strokes (K) in various directions. Small, curved lines (L) with 2B pencil, varying the pressure from left to right. Short, vertical strokes (M) with 2B pencil, varying the pressure, and direction. Vertical strokes (N), varying the pressure, leaving white areas. Combination of 2H, HB, and 2B pencils with short strokes (O) going in various directions.*

Creating Textures with Lines and Strokes

As you start to draw from nature, you will want to indicate textures such as stone, wood, grass, shingles, etc. Not only will this give your drawing authenticity, but it will also create interest. Remember, however, that you are not copying an object, but indicating it. This means that you do not strive for a photographic copy, but, by combining values and strokes, simulate the quality of the texture. When lines and tones are combined, you achieve the patterns necessary to draw convincing subjects (Figures 17 & 18).

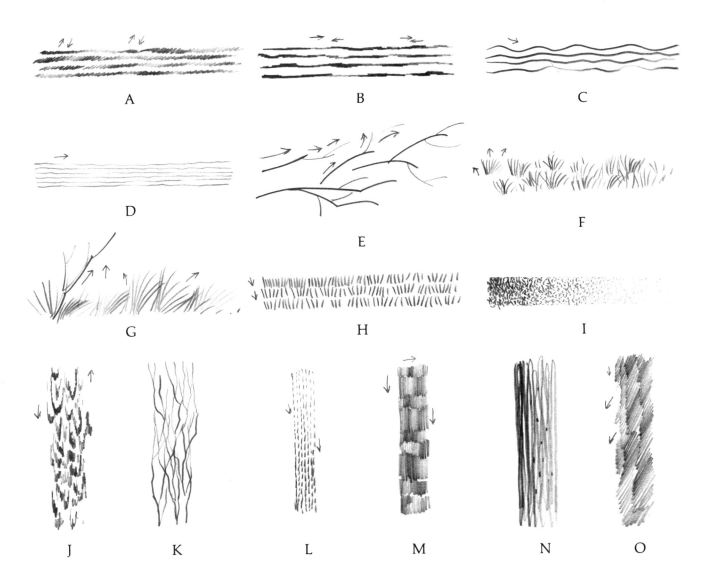

Figure 17. Creating Textures with Lines and Strokes.
Creating textures with the use of lines, not with tones, are shown here: A jagged line (A) using a vertical motion and varying the pressure. A jagged line (B), but using only a horizontal movement, also varying the pressure. Large, curved, continuous line (C) with a rounded point. A finer line (D), small curves, varying the pressure. Long arcs (E), dark with pressure, small areas changing direction, and lighter pressure. Short, curved strokes (F) from bottom to top, and varying the pressure and direction. Longer, curved strokes (G) from bottom to top, combined with long arcs. Short, *straight strokes (H), slightly varying the direction. Very short strokes (I), becoming wider apart, shorter, and less pressure as it gets lighter. Jagged, vertical strokes (J) moving down and then back up without lifting the pencil from the paper. A continuous jagged line (K), varying the pressure. Very short strokes (L), becoming longer, and using more pressure as they get darker. Short strokes (M), varying the pressure from left to right. Long irregular lines (N), flat point, with less pressure on the right. Short angle lines (O), varying the pressure, moving from top to bottom.*

Figure 18. Indicating Textures. *Here is a closeup demonstra-*
tion of how various strokes and combinations of strokes can be
used to indicate the textures of shingles, grass, and trees. Don't try
to draw a complete picture, but pick out closeup views of different
subjects.

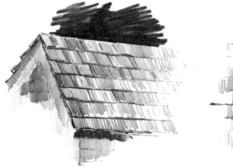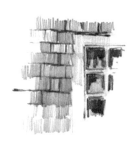

Shingles made with a combination of strokes from Figure 17: (O)
short angle lines, varying the pressure, moving from top to bottom;
(M) short strokes, varying pressure from left to right; and (B) a
jagged line but using only a horizontal movement, also varying
pressure.

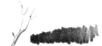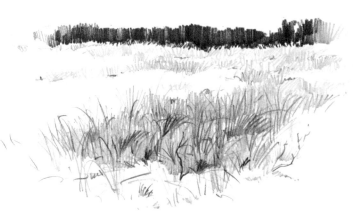

Grass in the fields made with strokes from Figure 17: (F)
short, curved strokes from bottom to top, varying the pressure and
direction; (H) short, straight strokes, slightly varying the direc-
tion; and (E) long arcs, dark with pressure, small areas changing
direction, and lighter pressure.

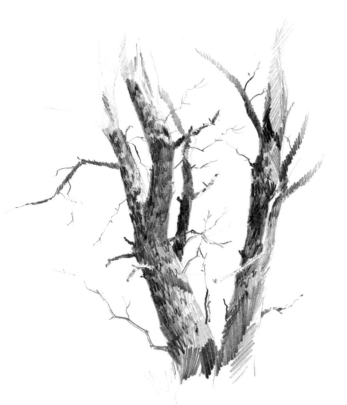

Tree trunk using strokes from Figure 17: (O) short angle
lines, varying the pressure, moving from top to bottom; (J) jagged,
vertical strokes moving down and then back up without lifting the
pencil from the paper: and (E) long arcs, dark with pressure, small
areas changing direction, and lighter pressure.

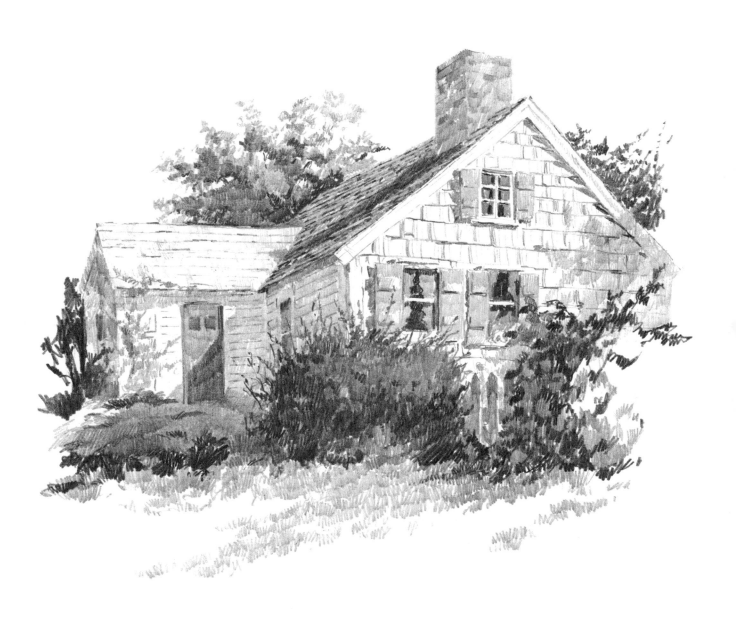

SAGGING HOUSE

This is an example of a drawing that uses the various strokes I describe in the text. For the shingles I use 2H and 4H pencils, the brick chimney is a combination of 2H and HB pencils, the roof a HB and 2B, the trees a 4B, and the grass a 4H. Many of these old houses tend to sag at the corners, giving them the appearance of tipping over.

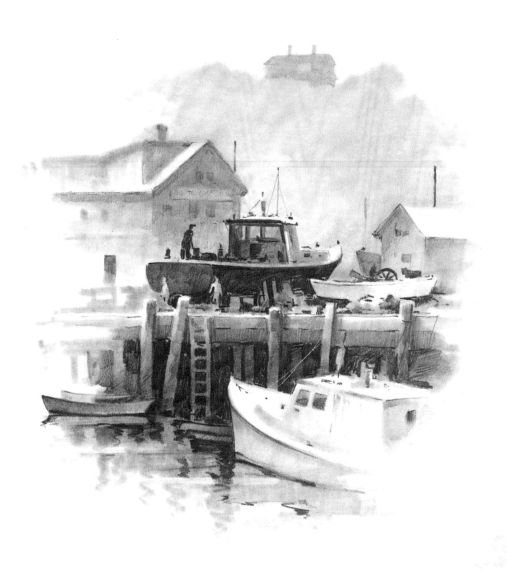

BEACON MARINA

This drawing, done in my studio, illustrates the effect you get by smudging the pencil. I use a 2B pencil, vary the pressure, and then smudge with a paper stump. Many of the lighter tones are done with the stump itself.

At right is the same drawing done on-the-spot. I use 6H and 4H pencils for my light values, 2H and HB pencils for the middle tones, and a 4B for the dark tones. I feel this drawing has a much nicer quality because the individual strokes can be seen.

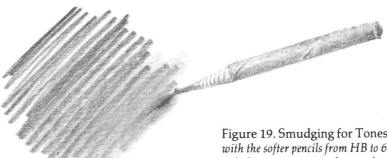

Figure 19. Smudging for Tones. *Smudging is done mostly with the softer pencils from HB to 6B. You can also smudge with a cloth or tissue wrapped around your finger.*

Smudging for Tones

Many artists use a paper stump and smudge or blend their pencil drawings to give a very even, almost photographic quality. I have occasionally used this method, but only where I want to create a soft blending of the edges of a vignette. I do not recommend this technique when drawing on location. There is a tendency in smudging to indicate every value change no matter how slight. This is difficult to do when you are outside and the light is changing rapidly. Also, the quality of the pencil strokes are lost by smudging and, therefore, the charm of the medium is lost (Figure 19).

Seeing the Landscape as Values

When you start drawing the landscape, you must first begin to see the landscape in terms of values—not lines. There is no reason why you, as an artist, cannot change the values you see before you. A musician will take a group of notes and bring them together in such a way to make harmony, and it becomes a composition. So you will take a group of subjects—a farm, trees, mountains, boats, etc.—and bring them together to make a composition. This will take some planning and arranging (Figure 20).

Let's take a simple example. Suppose you are drawing a gray barn of the 5th value against a mountain of the 4th value and a foreground of the 6th value. If you make all the values as they are, it will be a pretty monotonous drawing (Figure 21, top). a). Now start to change the values. Make the barn a 7th value, the mountains a 3rd value, and the foreground a 5th value. Notice how you are now getting some separation and interest (Figure 21, middle).

Go a step further and make the barn a 10th value, the mountains a 0 value, and the foreground a 5th value (Figure 21, bottom). You now have the widest range of values possible. There are a variety of value arrangements you can make in any drawing. It is up to you to decide where you want the emphasis and what effect you want to achieve.

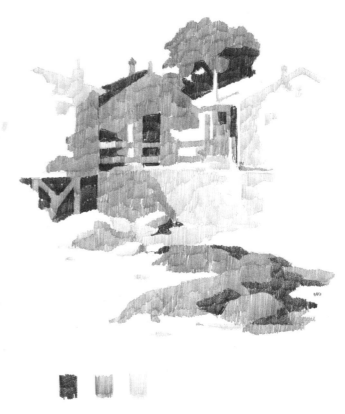

Figure 20. Planning Values. *This flat rendering of the "Lobster Shacks" drawing shows how I plan my values with three pencils. The darkest value is drawn with a 4B pencil, the dark middle tone with a 2H pencil, and the light value with a 6H pencil. Try to visualize all your drawings in as simple a statement as this diagram. Notice also how I plan the vignette with white areas coming into the drawing.*

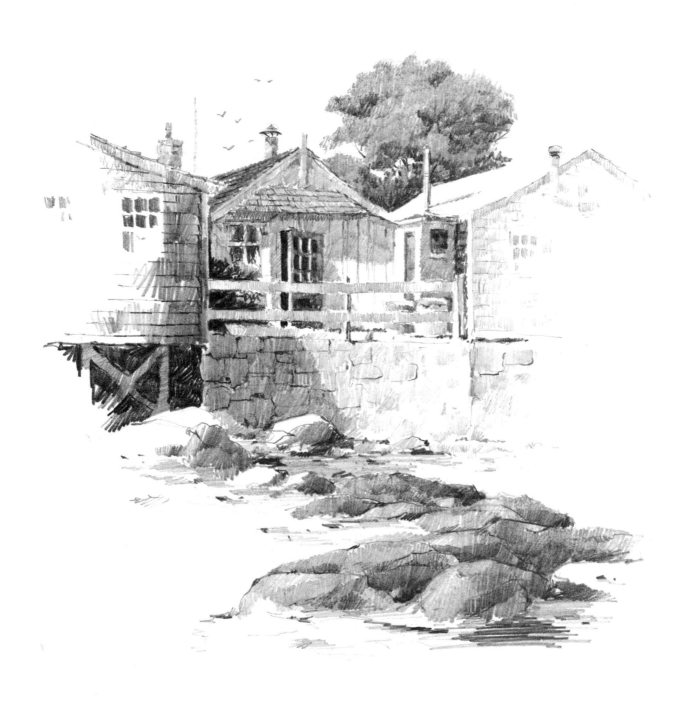

LOBSTER SHACKS

In this drawing I show how dark values can lead your eye through a picture. The dark rocks in the foreground lead the viewer's eye into the cast shadow on the wall, then through the center shack, and finally into the dark tree. All other values and the vignetting lead to this central pattern of darks.

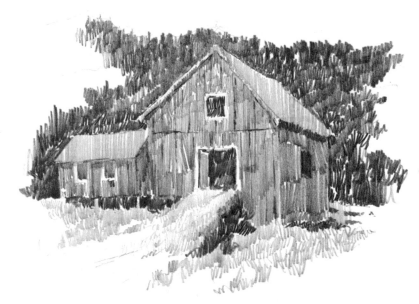

Figure 21. Indicating Values. *In this drawing the values are all too close together. The barn is the 5th value, the mountain the 4th value, and the foreground the 6th value.*

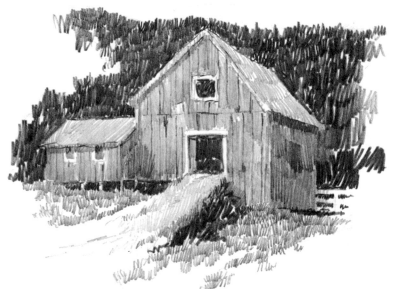

Here values are separated slightly, making the barn a 7th value, the mountain a 3rd value, and the foreground a 5th value. You are able to see the barn better now.

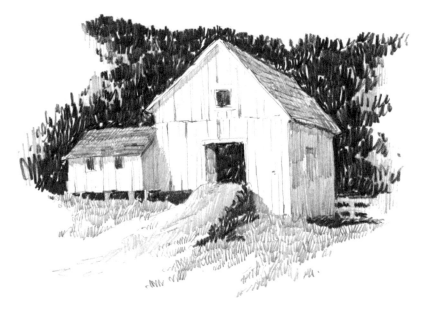

With the barn at the 10th value, the mountain a 0 value, and the foreground a 5th value, you now have the strongest statement you can make.

EAST GLOUCESTER

In this drawing the values are exactly as I see them. The values are the darkest in the foreground and lighter in the distance. I drew this on the spot.

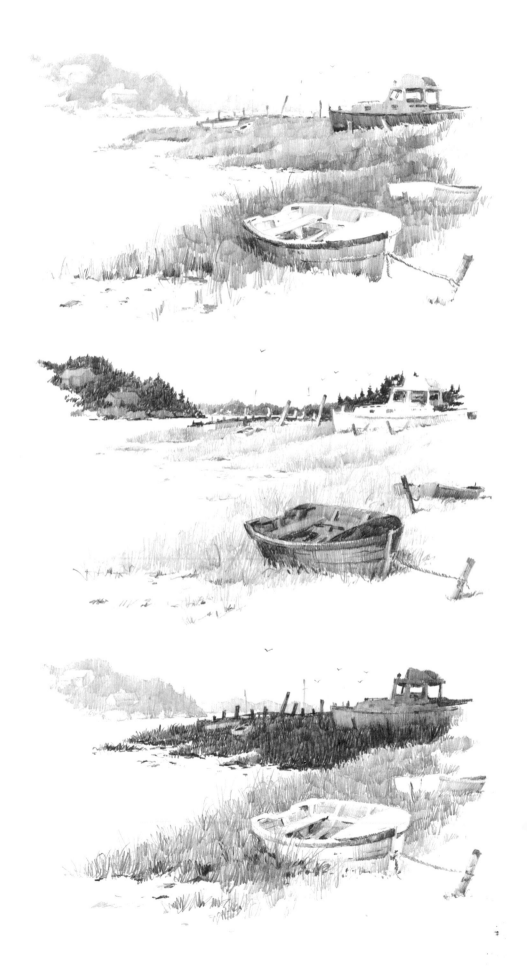

The same scene as above, but I change the values. I changed the background from the lightest to the darkest value. Notice that by changing values, you can obtain a different emphasis. There is never only one way for values to be correct. Experiment by changing the values until you arrive at the most effective composition.

Again, I change the values. This time I make the middle distances as the darkest value. I don't think this arrangement is as effective as the other two, since it gives an unnatural change of values. There could be a cloud that casts a shadow over that area, but it is not too probable.

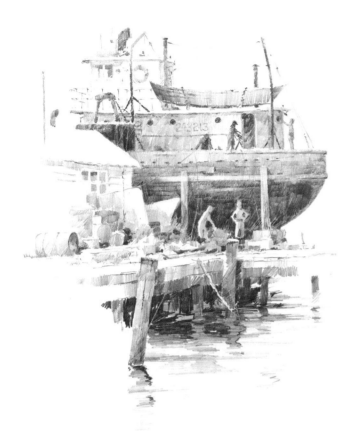
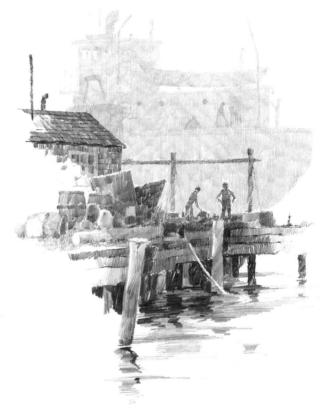

ROCKY NECK RAILWAY

The left drawing is done on-the-spot using the values the way they appear. Most of the middle tones, from the 5th value with an HB pencil, to the 2nd value with a 2B pencil, are kept in the background where I want the center of interest. The foreground values (except for the area under the pier) range from the 7th value to the 10th value.

The same scene is on the right, but I shift the center of interest from the large boat in the background to the foreground area. I draw the boat in the 8th value, with a 6H pencil, as a silhouette with very little detail. The foreground uses values ranging from 4 to 1 with HB, 2B, and 4B pencils. Don't be afraid to change the values of the large areas. By changing values you are able to create the effect of fog or haze, as in this case, or you can change the mood of the drawing by making it a low key (values from 5 to 0) or a high key (values from 10 to 5).

Seeing the Landscape as Vignettes

One of the most difficult areas of landscape draw-ing is visualizing the scene in terms of a vignette. A vignette is a "picture that shades off gradually into the surrounding ground or the unprinted paper" (Webster's Dictionary). In simple terms, a vignette does not extend to all four squared-off edges. A drawing can, however, vignette on one, two, three, or all four edges. The pencil lends itself more to the vignette than to a drawing that extends to all four edges.

Observe the different feeling you get between a squared-off drawing and a vignetted drawing. It is the effect you want to create that determines what kind of vignette you use. Most of my drawings are a full vignette because I'm partial to the white paper that gives the drawing breathing room (Figure 22 A, B, C, and D).

A

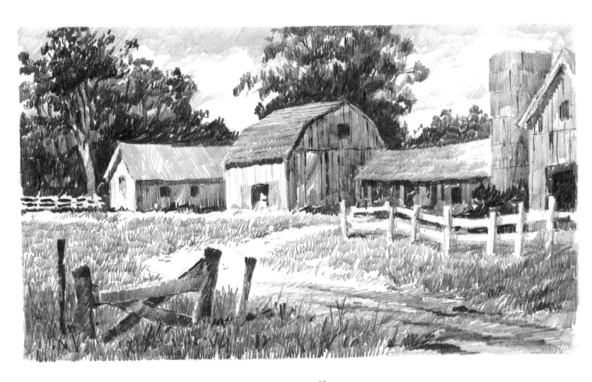

B

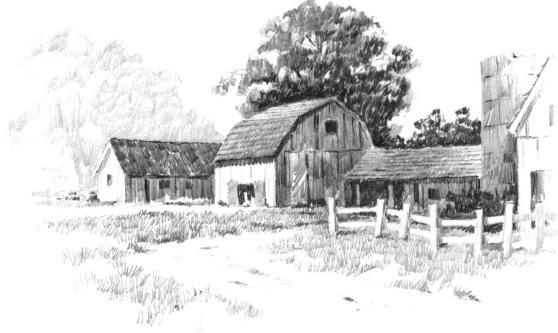

32

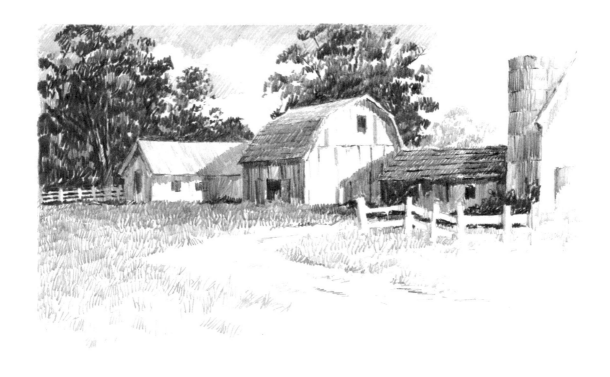

C

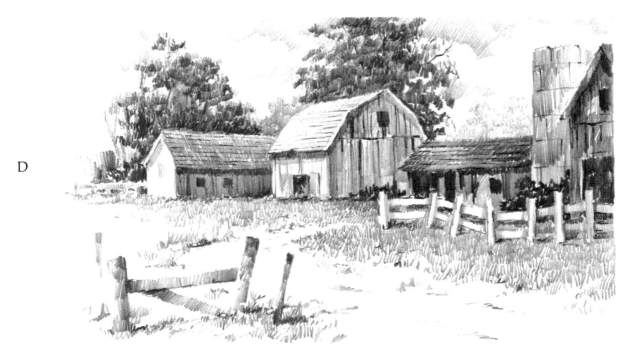

D

Figure 22. Seeing the Landscape as Vignettes. *(A) (top left) A squared-off drawing. There is no vignette because the drawing extends to all four edges and corners. (B) (left) A full vignette. The direct opposite from a squared-off drawing. The drawing does not extend to any edge, floating in a white frame area. (C) (top) Partial vignette. The vignette is on the right and bottom with the top and left squared off. (D) (above) Partial vignette. The vignette is on the left and bottom and the squared-off area on the top and right. Notice the small changes in composition when you change the vignette. I wanted a little more interest and nicer vignette in the lower left, so I added the fence.*

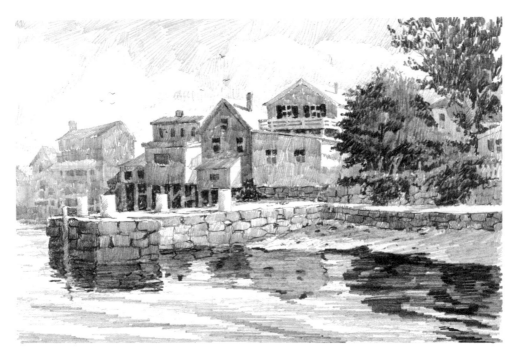

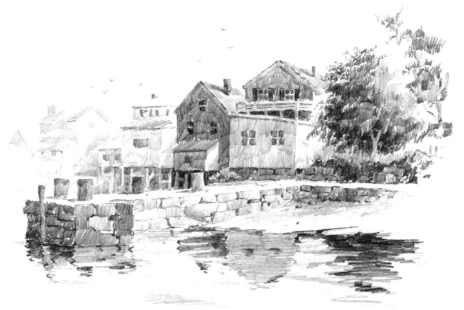

BACK BEACH

This on-the-spot drawing (top) has a squared-off composition. With a large sky area going to the top edge, I have to indicate a few clouds. I keep these light using a 6H pencil. In vignette drawings I seldom indicate the sky, because it is difficult to create an interesting vignette effect. I want the emphasis on the stone pier, so I make this a dark value using an HB pencil. The trees are a backdrop for the light middle tones of the houses. I therefore make the trees dark with an HB pencil and use 2H and 4H pencils for the houses. This gives me an interesting spotting of the values. The water is kept to a middle tone using horizontal strokes with a 2H pencil.

Above I want to create the same scene but as a full vignette. The values will remain the same except where they vignette off the left and right edges. I did not put as much detail or use as dark a value in these areas so I would have a light, airy vignette. The pencils I use to create the values are the same as in the other drawing.

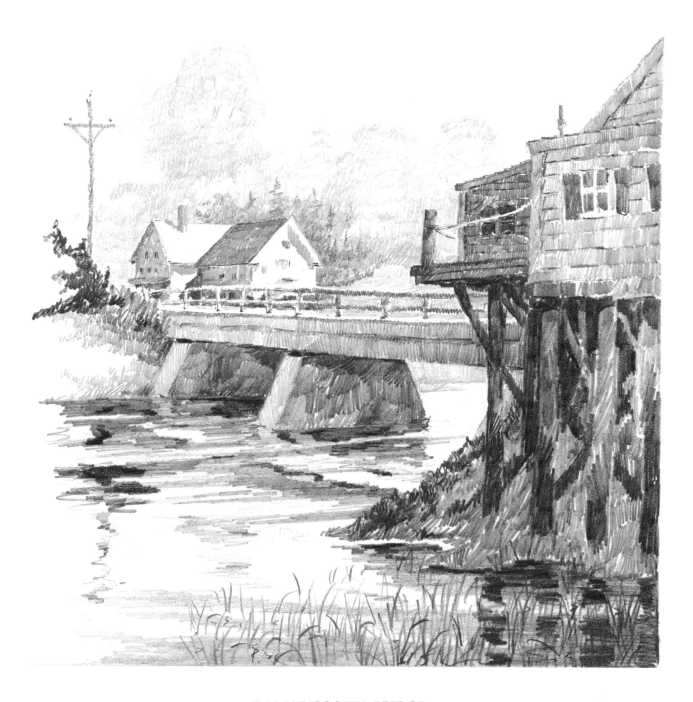

DAMARISCOTTA BRIDGE

In this vignette I feel it is better to square-off the right and bottom edges, since both of these areas are in shadow. I have found it is easier to vignette the light value areas than the dark value areas. I start the drawing with the dark areas on the right first using HB and 2B pencils. For the very dark areas under the house, I use a 4B pencil. After establishing my darks, I proceed to the bridge with middle tones using a 2H pencil, and I finish with the light values of the trees in the background. In the simple silhouette of the trees where I use a 6H pencil, I am able to obtain an interesting vignette and also create the feeling of depth.

Building the Drawing

I can recall leaving at seven o'clock one morning, full of vim and vigor, eager for a full day of sketching and drawing. I proceeded to drive and drive and drive, always looking for a better spot. Finally, at four o'clock in the afternoon I wound up back home. There, I did a drawing of an interesting tree in my backyard.

It is often frustrating to spend hours looking for a perfect subject to draw. In art shows, I have seen that the simple subjects are often the most effective. So, rather than drawing the complete city skyline, concentrate on making an interesting, delicate, and sensitive drawing of one building.

In this chapter I want to show how I go about selecting my subject and each step leading up to the finished drawing, including viewing the subject, sharpening the pencil, preliminary value and vignette studies, some do's and don'ts, and a step-by-step demonstration.

Selecting the Subject

The type of subject you choose to draw is a very personal matter. I have known artists that draw nothing but barns, others who only draw boats, etc. Once you have learned to see and observe the basics of drawing, you should be able to draw anything that is before you. I have stayed away from drawing only one subject. One advantage of always carrying a sketchbook or pad with you when traveling is the chance to draw many different subjects.

As soon as I arrive at a location where I want to draw, I make sure to look all around the area. I often incorporate elements from various spots into one picture. Then I look for the subject that interests me the most. In a harbor full of boats, it may be a lobster buoy laying on a pot, or a broken fence in a barnyard full of cows and horses. I often draw just the doorway or a window in a large, beautiful house, or a closeup of a few branches on a tree. The point is that I do not look for a large panoramic scene, as impressive as it may be, but rather a small area where I can focus my attention. Often, the amount of time I have enters into the selection of my subject. I usually allow myself two hours to

complete a drawing on location. If I start late in the afternoon when the light is almost gone, I will make quick notations and not try to indicate any details. I do like to draw, however, early in the morning or late in the afternoon since the long shadows at this time of day create a strong pattern of lights and darks. When the sun is overhead around noon time, it is more difficult to see the form and characteristics of the subjects.

One of the main principles I follow when I draw outside is not to select a subject that is too difficult or odd. I try to stay away from houses or barns that have unusual angles of the roof or dormers, trees that are cut or grown into an odd shape, or objects that look incorrect in either size, perspective, or design. If the subject is confusing when you look at it, it will be more confusing when you attempt to draw it. I know a beautiful barn where the corners are not at right angles. No matter how many times I have drawn it, the perspective does not look right. If I were to make an accurate drawing of this barn and put it in a show, I'm sure I would get all kinds of criticism for my poor perspective. I would not be there to tell my critics that the barn is actually constructed this way. So, I stay away from subjects that do not look right to me.

Viewing the Subject

Once I have selected my subject, I will look at it from several different angles. Perhaps a different angle, perspective, or light may give me an unusual picture. I want to see if the point of interest should be large or small, whether I want to move closer to the subject, or have more room around it. Do I want a high eye level or a low eye level? Is there some interesting object that is perhaps behind me that I want to include in the picture? Most important, however, I try to get an angle where there is a pattern of dark against light and light against dark. If it is not possible to see a pattern of alternating values, make a small thumbnail sketch to see how the values could be changed to make a simple and interesting pattern. Don't rush. Be sure the statement you want to make is clear to understand.

Sharpening the Pencil

When I start out on a trip, I sharpen all of my pencils to a point. I am partial to a sharp point on a smooth surface paper, because I can get better detail and a more sensitive tone. With the softer leads, 2H, HB, etc., I let the point become rounded with wear as I am drawing.

Preliminary Value Studies

After I am satisfied with the drawing, I take several minutes and make a few value compositions. These are done using three values only. The dark value is indicated with a 2B pencil, the middle tone with a 2H pencil, and the light value with a 6H pencil.

Preliminary Vignette Studies

Since most of the drawings I do are vignettes, I usually plan them very carefully. A single black and white sketch will show me how the outside shape will look. It is much like making a high contrast photo where there are no middle tones—tones become black and no tones become white.

Some Do's and Don'ts

There are several "do's" and "don'ts" I want you to observe before you start to draw (see Figure 23). I'd advise when you begin, to work on a 9" x 12" (23 x 31 cm) or 11" x 14" (28 x 36 cm) paper. It is much easier to indicate a small area than a large one. Also, you are able to see the composition more quickly in a smaller drawing.

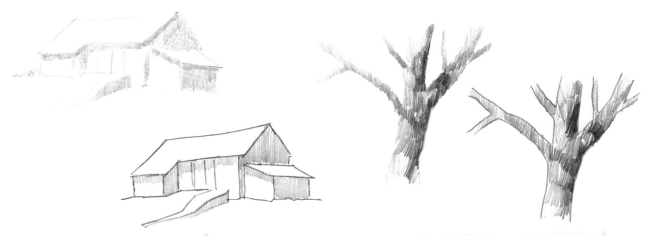

Figure 23. Do's and Don'ts. *1. Do keep all beginning lines thin and light. I use a 4H pencil sharpened to a fine point for all my lay-in drawings. Don't use a soft pencil so that the beginning lines become heavy and dark. In the final drawing the lay-in lines should not be visible.*

2. Do put only enough material in the initial drawing so you have enough information for you to start the tones. There will be edges that will be lost or simply left to the imagination. Don't outline everything. Avoid the cut-out and pasted down look. Some areas should blend into the paper without a hard edge.

3. Do spot key points on the paper so that you will know approximately where all the major areas will fall. Don't start at one corner, finish that area, and then find out you have run out of paper at the other corner.

DEMONSTRATION 1. BUILDING YOUR FIRST DRAWING

I have chosen a relatively simple subject for my first demonstration. I will indicate the textures of wood, stone, shingle, trees, and grass. Each is rendered in a different manner.

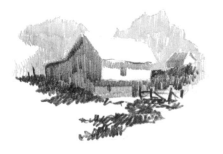 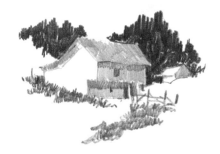 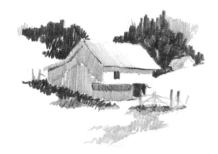

Preliminary Value Studies

In the first drawing I make the values exactly as they are. A strong light comes from the right and strikes the front of the barn. There are light trees in the background, and dark dirt and grass in the foreground. This does not seem satisfactory, since the dark side of the barn and the foreground all run together and the light side of the barn and background do the same. In the middle drawing, I try a different approach and make the background trees my darkest value. To give a separation between the dark side of the barn and the foreground, I decide to change the light so it comes from the left. This does not appeal to me because the light side of the barn is uninteresting and yet it has become the focal point. In the final sketch I decide to keep the background trees dark, since this gives me a nice sharp silhouette of the barn. I like the light coming from the right, the way it actually appears. I keep the middle tones in the shadow side of the barn and under the eaves in the front, and the light values in the foreground. This gives me a nice simple pattern of lights, middle tones, and darks.

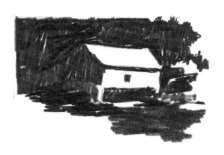 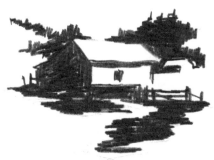

Preliminary Vignette Studies

In these studies I am not concerned with values. My first thought is to square off the top and left side, since the barn faces right and the light is coming from that direction. Because the barn has many square corners, I thought it would be more interesting if there was a softer vignette around the barn, so I attempt another one.

The second vignette has too much of an overall solid feel to the outside shape. I did not allow for any white areas coming into the center of interest. It has too much the feel of an overall tone.

The final version is much more successful. The outside shape is better and there are some interesting minor silhouettes with the fences against a white area. A white path left in the foreground leads my eye directly to the center of interest. With my values clear in mind and the vignette achieved, I am now ready to start the drawing.

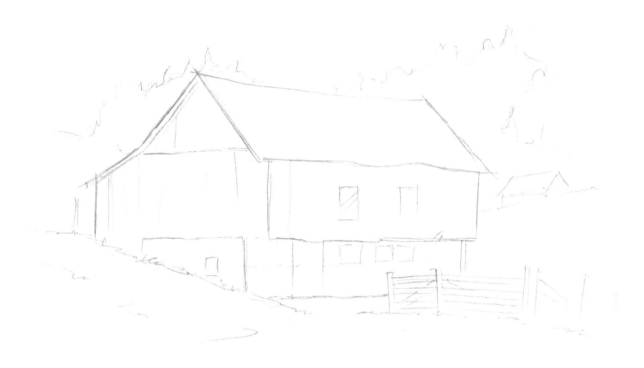

Step 1. The First Line

The initial drawing is done with a 4H pencil. I include only the important lines of the barn and do not draw every board, stone, etc. I am concerned only with the proper proportions, placement on the paper, and perspective.

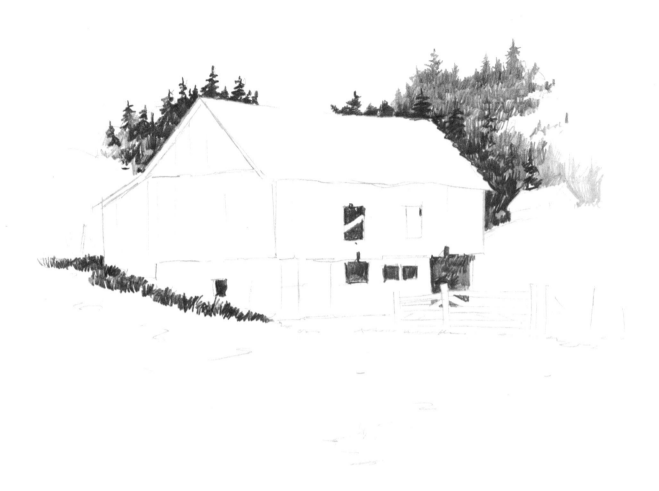

Step 2. The First Value

The first value I establish is the darkest tone. For every area that appears dark, I use an HB pencil. When all the sections are covered, I make the trees behind the barn one value darker with a 2B pencil. Later on, I will add small spots with a 4B pencil, but this will not change the large abstract shape of the darks..

There is a basic reason for starting with the darkest areas. My light area is pretty well established. I cannot go much lighter than the white paper or possibly one value lower with a 6H pencil. The two unknown values I will later establish are the middle tones and the dark tones. When I lay-in the darkest first, I immediately establish how dark I am able to go with the middle tones. The middle tones are the critical areas. If they are too dark, the drawing will become too low-key, and if they are too light, the drawing will look washed out.

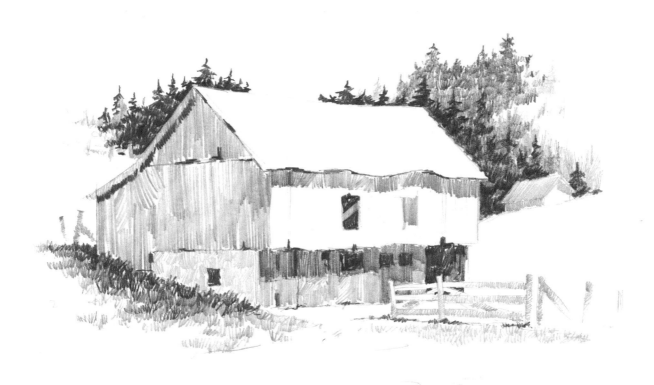

Step 3. Building the Drawing

Once the darks are established, I put in all the middle tone areas. Since the boards on the side of the barn were vertical, I draw all my strokes the same way with a 2H pencil. I vary the direction occasionally to add interest. The stone area (left), the fence, and the beginning of the grass are added with a 4H pencil. With an HB pencil, I darken the shadow from the overhang on the front of the barn. No detail is added until I am satisfied with all of the value areas.

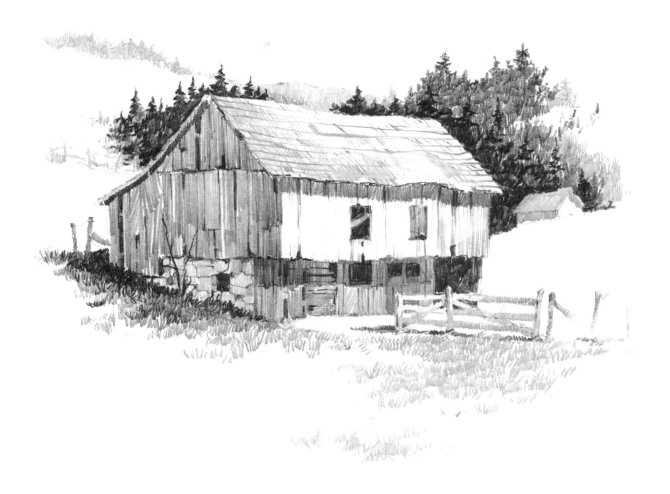

Step 4. Finishing the Drawing

After all the values are laid in and the vignette established, I then begin working on the detail and the texture. I indicate some of the boards on the shadow side of the barn with an HB pencil. To add interest, I indicate some of the boards missing. This is a case where a little artistic license is necessary. Even though there are no boards missing, I feel the barn will look too boring if I leave the sides as they are. Anyway, to me, an old house or barn, an old craggy face, or an old tree is much more interesting than a new or young one—to draw, that is.

Then, with a 6H pencil I indicate the right edge of the barn. Using a 2H pencil I then add the missing boards. The details in this area are left to a minimum. If you indicate too much detail, it will cut the value down, thus reducing the effect of the light on the front side. Finally, with a 6H pencil I indicate the roof, the hills, and trees in the distance, and I finish the grass in the foreground. I then place the drawing in a mat and move away from it to see if the values hold together from a distance. With all the visualizing, preparation, and planning, I completed the drawing in approximately one hour.

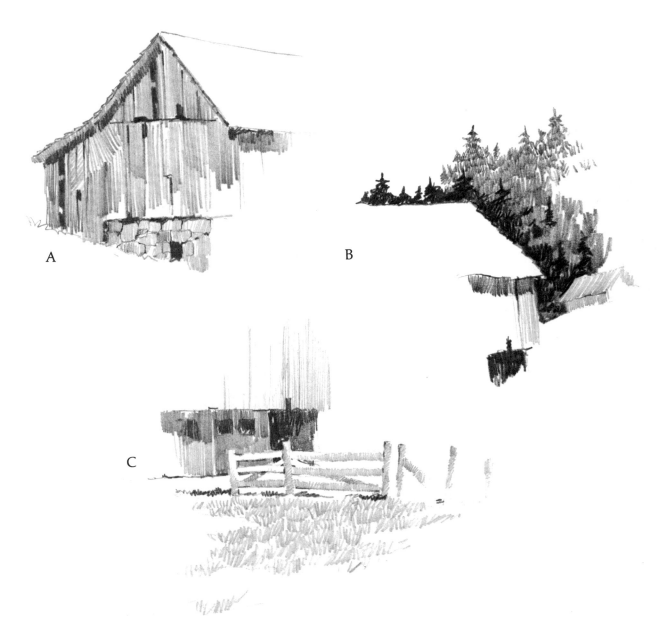

A

B

C

Details of the Finished Drawing

A. The side of the barn is drawn quickly with a 2H pencil using vertical strokes and varying the amount of pressure. This gives a slight tonal change that occurs in barn siding. I do not go from the top to the bottom in one stroke. I change the length and direction of lines, again giving more interest to the area. After I put in the divisions of the stones with an HB pencil, I darken an occasional stone with a 2H pencil.

B. The trees in the background are indicated with very short strokes going in all directions. I cover the entire tree area with an HB pencil. Over this area, I take a 2B pencil and in the same manner draw the darker trees next to the roof of the barn. Notice how the value relationships are quickly established with the dark areas against the white paper.

C. The fence is indicated with a 4H pencil. The strokes are vertical, but the direction is slightly varied. I leave the fence white in front of the dark area of the barn. With a 4H pencil, I draw the grass with short strokes going in all directions. Observe how the fence is not outlined. The entire fence is held together by tones. On the right, the fence itself is indicated, and on the left the dark background constructs the fence. I cannot repeat often enough: Do not outline objects and then fill in with a tone.

Trees

If you do landscape drawing or painting, sooner or later you are going to draw trees. In this chapter I want to cover certain aspects of a tree that are important to anyone who wants to make his drawing look convincing.

All trees are basically made up of the trunk, branches, and the crown. When you first draw the tree, look at the simplified silhouette, the relationship of the trunk to the branches, the area between the trunk and the crown, the sky holes (open areas) to the larger masses of the crown, and so on. As a portrait painter will measure the distance between the eyes, nose, mouth, etc., the landscape artist must measure the proportion between the height to the width, how far up the trunk the branches begin, the thickness of the trunk to the main branches, and the main branches to the ends of the branch. This may seem obvious to you, but I have seen trees that are poorly drawn for two basic reasons: the silhouette is not interesting (it looks like a lollipop), and the trunk is either too large or too small for the crown.

It is important, however, not to make up a tree or use a stereotype tree, but go out into the field and actually draw a tree that you can identify. In this chapter I will discuss the types of trees and show you principle steps in drawing them, followed by three step-by-step demonstrations.

Types of Trees

To list the different types of trees would be endless. It is not necessary to know every type of tree any more than it is necessary to know every bone in the body in order to draw the figure. I am going to break the types of trees into three basic groups: 1. Broadleafs, which include maple, oak, willow, elm, sycamore, etc.; 2. Conifers, which include pine, spruce, fir, etc.; and 3. Palms, which include coconut, jade, and palmetto.

To be sure, there are many more examples of trees in each of the three groups. If you understand the basic approach and characteristics of each group, however, you should be able to draw all types of trees.

Principle Steps in Drawing Trees

Before I start a drawing of a tree there are four basic steps that I note. As each tree is different from every other tree, I look for the character of the tree I am drawing (Figures 24, 25, 26). To do this I follow this procedure:

The General Shape. I look at the overall shape of the tree. It is much like taking an imaginary piece of plastic wrap and completely enclosing the tree. When I see the tree this way, all the intricate outlines are reduced to a simple flat pattern. Into this flat pattern the smaller individual branches can be fitted. This is true whether you are drawing a tree in the summer with all its leaves, or in the winter when just the skeleton is visible.

The Silhouette. The next step is to determine the silhouette. A careful study of the silhouette is important because it gives you the individual character of the tree. Each tree looks different because the silhouette of each tree is different. In the silhouette you can see the number as well as the size of the sky holes, the branches that extend further than others, the bare branches where there are no leaves, etc.

The Width and Height Proportion. The proportion of the width to the height is very important. I check the height with the width by simply squaring off the tree, using my pencil to measure. With my arm fully extended and my pencil in a horizontal position, I line up the top of the pencil with one side of the tree, and move my fingers up the pencil until they mark the other side of the tree. This length on the pencil corresponds to the width of the tree. Without shifting my fingers, I turn the pencil to an upright position, keeping my arm fully extended. I can then see the relationship of the width to the height. I always start with the shortest dimension first, so I can compare that to the longest.

Pattern of Lights and Darks. As I get into the rendering of the tones in the tree, it is important to see a simplified pattern of lights and darks. I make sure there is a definite area of light and dark. I try to keep these areas separate so that there are no lights in the dark area and darks in the light area.

Figure 24. Broadleaf Trees.

 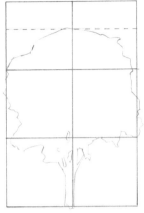 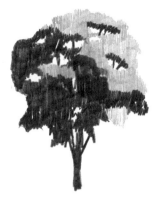

1. The General Shape

2. The Silhouette

3. The Width and Height Proportion

4. Pattern of Lights and Darks

Figure 25. Conifer Trees.

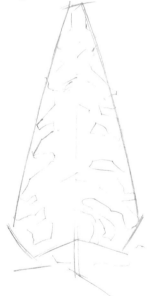 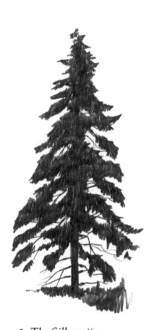 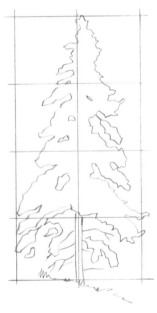 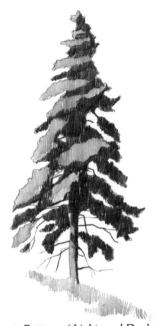

1. The General Shape

2. The Silhouette

3. The Width and Height Proportion

4. Pattern of Lights and Darks

Figure 26. Palm Trees.

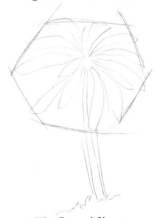 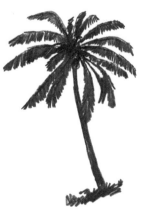 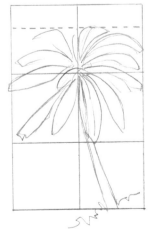 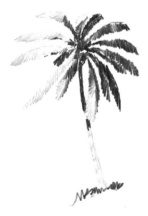

1. The General Shape

2. The Silhouette

3. The Width and Height Proportion

4. Pattern of Lights and Darks

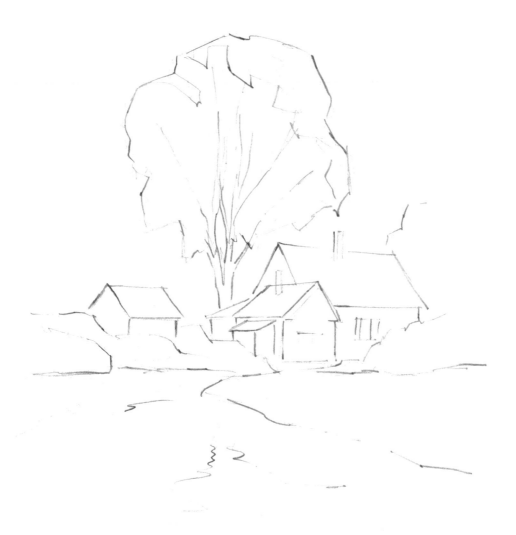

Step 1.

The initial drawing is made with a 4H pencil. Rather than demonstrate only a tree, I will include some of the surrounding area. The proportion between trees and houses is very important because it will give you the relative size of each. There are two points I want to establish immediately: 1) the fullness of the crown of the tree, i.e. the width to the height; and 2) an indication of the shadow side and the light side. In addition to the outline of the crown, I also draw some of the main branches leading out to the ends of the tree. This will indicate where some of the branches will show when I lay-in the tones.

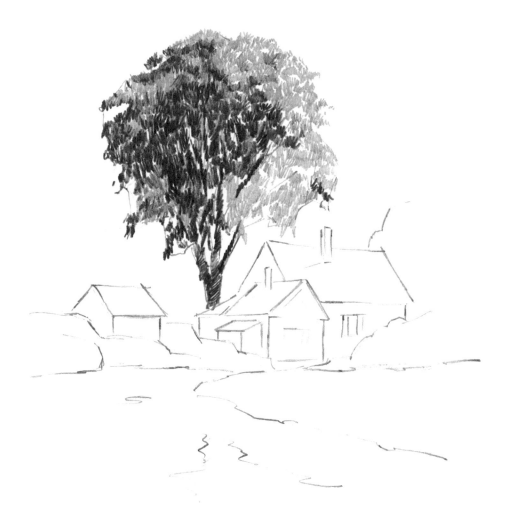

Step 2.

First, I start with the values of the tree. I use two pencils: a 4H for the light side, and an HB for the dark value. I draw the *complete* tree with the 4H pencil, because it will render the silhouette; therefore, I can see where the sky holes will be and what the edge will look like. After I complete this, I take the HB pencil and lay-in the shadow side of the tree. Because the light tone is already under the dark side, I leave some of the light tone showing, which gives a nice breakup of the dark area.

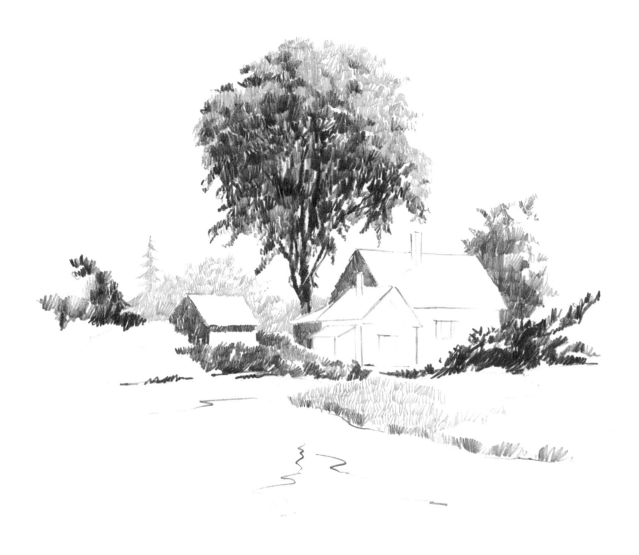

Step 3.

Now that the tree is drawn, I can start on the surrounding area. I establish most of my darks with the HB pencil. I am once again aware of the vignette, so I do not leave any straight, cut-out edges. With a 4H pencil, I lay in the background trees and begin the foreground. I leave the light side of the house white, because I'm not sure how much detail I want to put in this area.

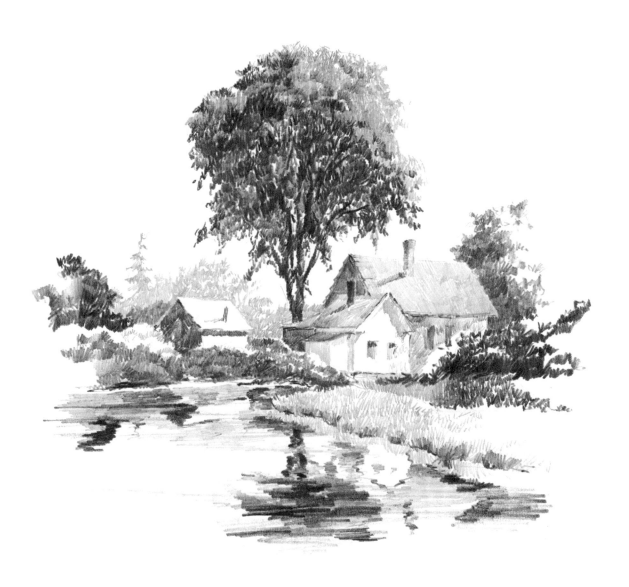

Step 4.
I indicate the reflections in the water with horizontal strokes to give the water a flat look and also to contrast the vertical strokes of the grass and bushes. When the foreground, background, and tree are finished, I put a tone in the light side of the house. Then, I draw in the roof with a 6H pencil, and the shadows and detail with a 4H pencil. Because the tree is standing by itself, I feel it remains the center of interest, even with so many dark and light values in the rest of the picture.

Details of the Broadleaf
It is impossible and unnecessary to indicate every leaf on a tree. With short strokes going in different directions, I can get the feeling of leaves without a lot of detail. I do this on both the light side and the dark side of the crown.

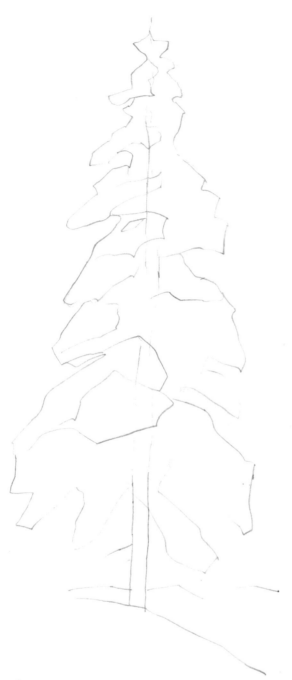

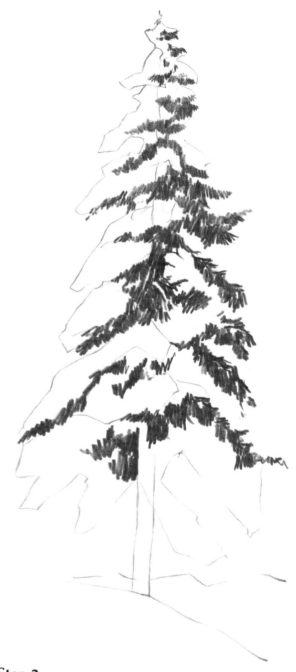

Step 1.
After I see the characteristics of the tree, I sketch in the trunk first with a 4H pencil. This gives me the direction and angle of the tree, and it acts like the backbone in figure drawing. I then draw the basic shapes of the branches and indicate where the light and shadow areas occur.

Step 2.
With short strokes, I lay-in all the shadow areas with an HB pencil. I try to simplify these dark patterns. In observing a tree, notice how the branches grow; some reach skyward, down, some toward you, and away from you. There are areas where the branches have broken off and other areas where branches never grew. With close observation and careful study, you will achieve more interest in your drawing.

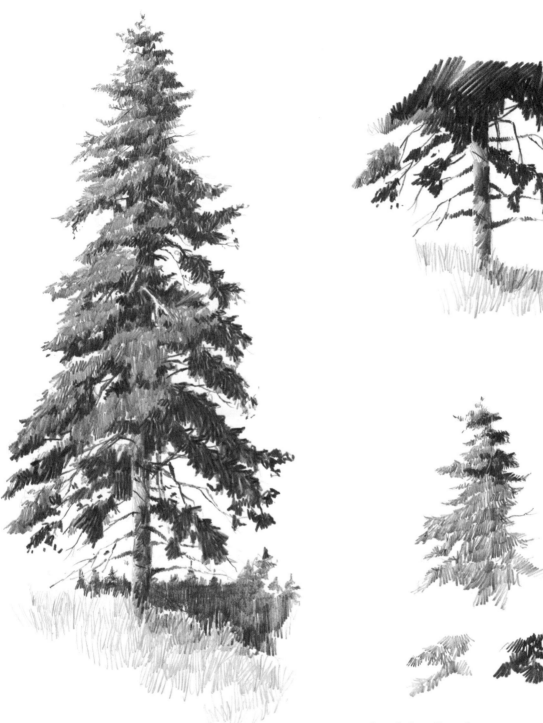

Step 3.
When the pattern of darks is established, I put in the light side with a 2H pencil. The difference between the light and dark sides should not be more than two values. On the light side, the strokes are short and fan out as the branches become smaller. I then put in all the small, broken, and bare branches, connect some of the longer branches to the trunk, and add the foreground and background.

Details of the Conifer
The trunk and the bare branches are not outlines. The strokes and tones hold the shape and edges. Notice the short strokes used to indicate the needles. Be sure to make the strokes fan out on each side of the branch.

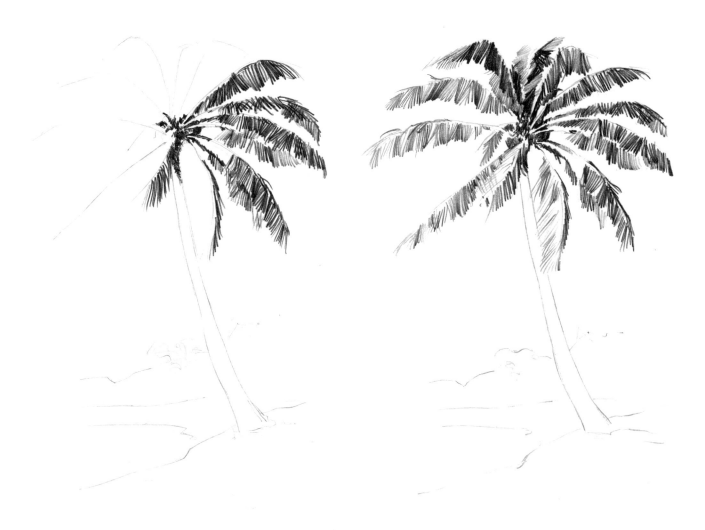

Step 1.
I sketch in the basic proportions and characteristics with a 4H pencil. My main concern is the length of the branches from the center, rather than the outside shape. In drawing palm trees, there is no definite shape to the crown as with broadleafs. Using an HB pencil, I start the darkest tones in the center of the tree where all the branches come together. The dark side of the tree is rendered with strokes that start at the spine of the leaves. Some of the main branches are left white in the dark area.

Step 2.
With a 2H pencil, I draw in the light side of the tree, indicating the leaves in the same way as the dark side. Where some of the branches overlap, it gives the look of cross-hatching, which is characteristic of this type of tree.

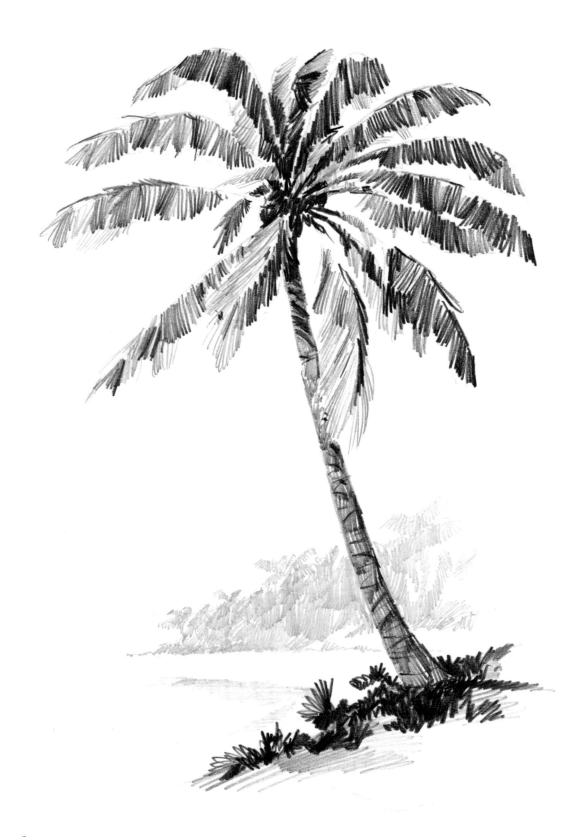

Step 3.
After the leaves are completed, I render the tone in the trunk. With a 2H pencil, I use short vertical strokes. To show roundness of the trunk, I apply more pressure to the strokes on the right side. This gives me a slightly darker tone. I indicate cast shadow near the center with an HB pencil, and I also put in some horizontal lines for the bark. With a 6H pencil, I put in the background using one tone and very little detail. I finish the drawing with nondescript foliage in the foreground with a 2B pencil.

Details of the Palm

A. Before I start the drawing of a palm tree, I make sure I understand how the branches are extending from the main trunk. This area is relatively small, as compared with other types of trees. Notice how some branches go to the right, the left, back, and foreward.

B. There is generally a dark side and a light side to the fan shape of the leaf. By following the spine of the leaf, the characteristic of the palm is achieved.

C. Start at the spine, and draw the strokes fanning out and coming to a point at the end.

D. The basic roundness of the tree trunk is indicated before adding any texturing.

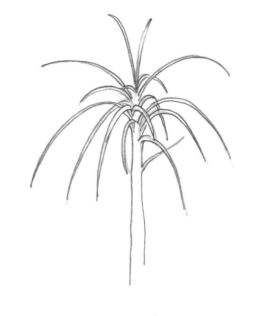

B

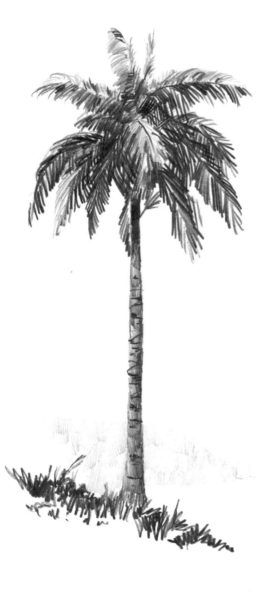

A

C

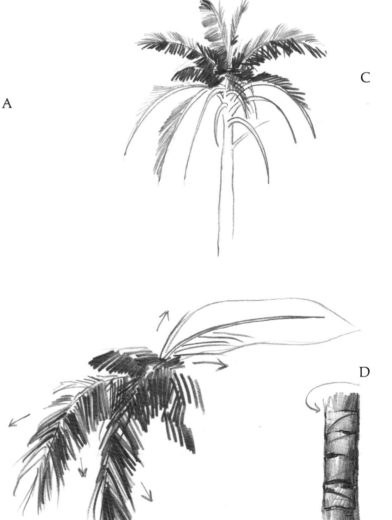

D

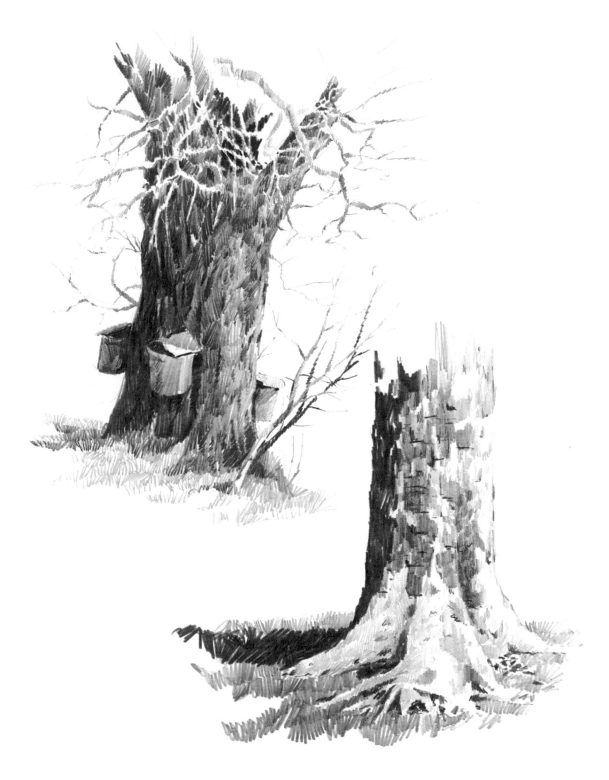

TRUNKS

This drawing is a rendering of two types of tree trunks. As you draw tree trunks, keep in mind their shape. All trunks are basically a cylinder, so I make sure to create that form first. With a 2H pencil I lay-in the trunk to look like a cylinder. On this base I now can create the various textures that are characteristic of each type of tree. I use HB and 2B pencils with short strokes to indicate the back, smooth and rough areas, but always keeping in mind the round form underneath.

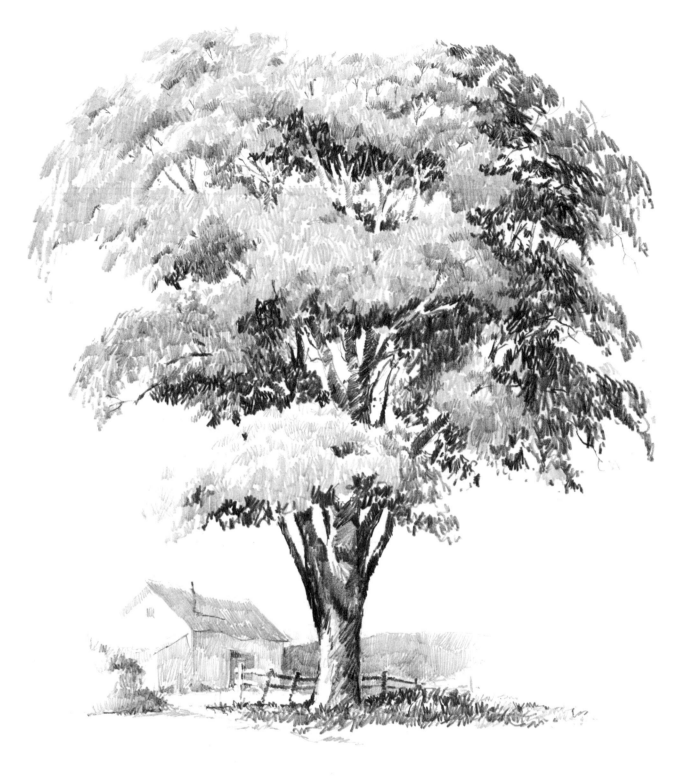

THE ELM

The elm tree is a classic example of a large umbrella-shaped crown that creates a beautiful and graceful silhouette. Once I lay in the overall shape of the tree with accurate proportions between the crown and the trunk, I draw the entire silhouette of the crown with a 2H pencil. This is the lightest tone of the crown. On top of this I draw the shadow area with an HB pencil. It is not necessary to completely cover the shadow side because a few missed places let a little of the lighter tone show through. Unfortunately we've lost so many elms over the past several years due to Dutch elm disease.

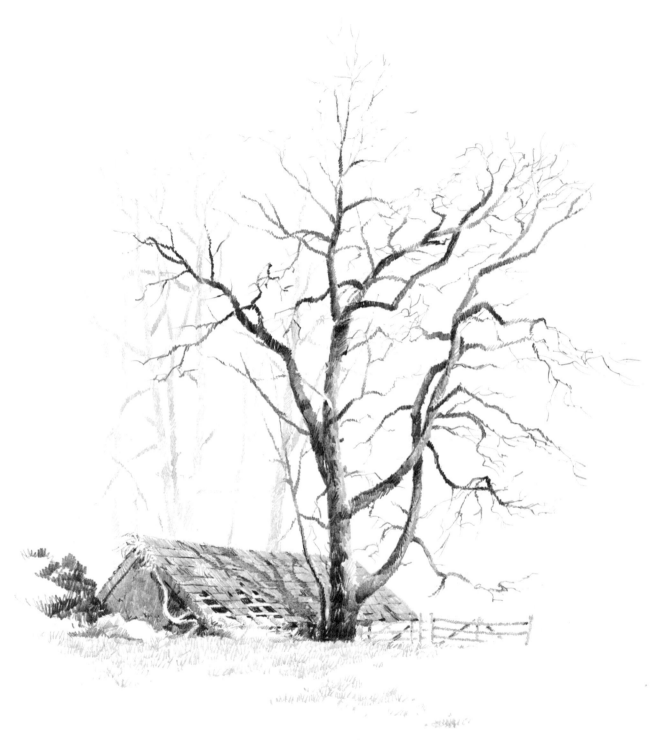

SPIDERY FINGERS

Probably the best time to study trees is in the winter when there are no leaves. It is interesting to see how the main trunk splits and the branches keep getting smaller and smaller as they reach the end. Be extremely careful that all the branches do not come out from the sides of the trunk. As you draw a leafless tree, have some of the branches come toward you and some go away from you. After I lay the drawing in with a 4H pencil, I start on the main trunk first and then draw the smaller branches. Using a 2H pencil, I draw the trunk with strokes going in different directions. I make sure, however, to retain the basic cylinder shape. The small building and fences I draw in with 2H and HB pencils. All accents I render with a 2B pencil.

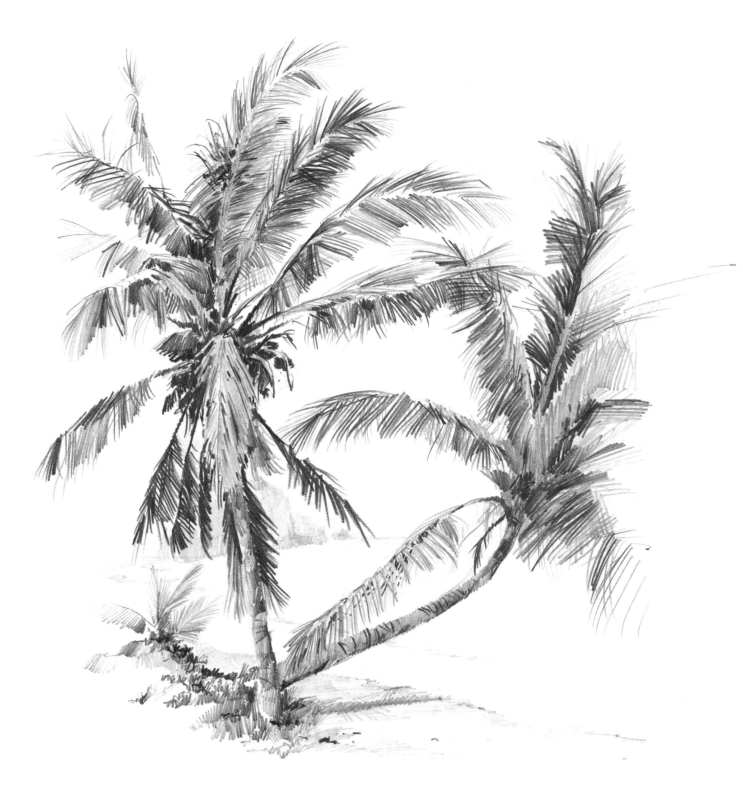

THE PALMS

The large overall shape is drawn first and the action of the trunk is indicated. Characteristic of palm trees, they often bend and lean due to the narrow trunk. Once I establish the action of the tree, I draw the large palm leaves from the center out to the edges with a 2H pencil. All dark areas are then put in with an HB pencil. The trunk is rendered using many short strokes with a 4H pencil. A common characteristic of palms are horizontal lines, which are drawn in with an HB pencil.

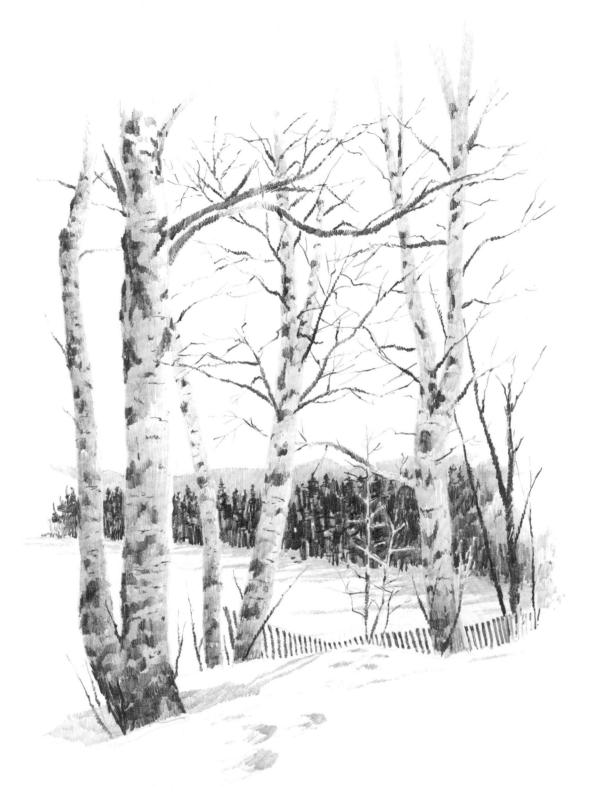

SNOW TRACKS

The striped white bark of the birch tree is its chief characteristic. Although the trees are white, I put a slight tone in the trunks with a 6H pencil to offset the white snow. I indicate the small darks of the trunk with an HB pencil and draw the end branches with a 2H pencil. To add a little interest, I put in the background trees and the snow tracks with a 4H pencil. Movement is important, so I carefully place these tracks to move the viewer's eye into the picture. Drawing in the winter can be a problem, so I like to draw sitting in a warm car, if possible, since I have found it extremely difficult to draw with numb fingers.

Mountains, Hills, and Rocks

When drawing high, lofty peaks, small hills, and rocks, you may encounter many difficulties. Before you start to draw such a scene, several problems must be explored. First, a center of interest is still important. Even though all the areas become smaller in size, relative sizes should be considered since it is sometimes difficult to see how large a mountain is if there is no comparative object. Since there are so many different value changes in a large area, it takes a great deal of planning to simplify the drawing. Be sure your drawing does not like a lot of disconnected areas and objects spread all over the picture.

In this chapter, I will show you the preliminary value studies of mountains and hills and step-by-step demonstrations of mountains, hills, and rocks with detail drawings.

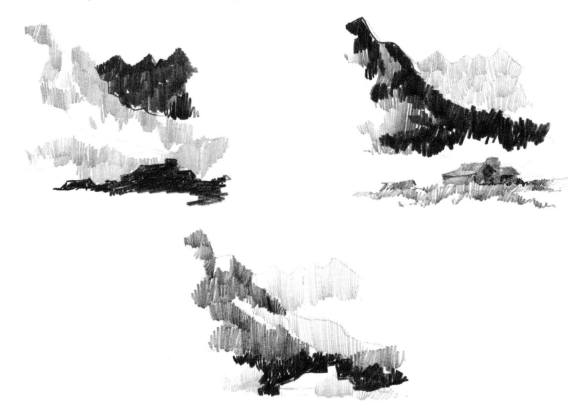

Preliminary Value Studies

First, I make a few value studies. Although the snow-capped mountains are the important area, I want the center of interest to be smaller. The farm in the foreground is a good device to give me both a center of interest and a comparative size to the mountains in the background.

The first value sketch is discarded. It separates the dark areas, which takes the interest away from the farm. The second sketch is more effective, but I still don't like the separation between the foreground and the background. The third sketch does everything I want. It achieves a relationship in size between the mountains and the farm; it gives me depth to the drawing with the light tones in the distance; and it centralizes the darks around the center of interest.

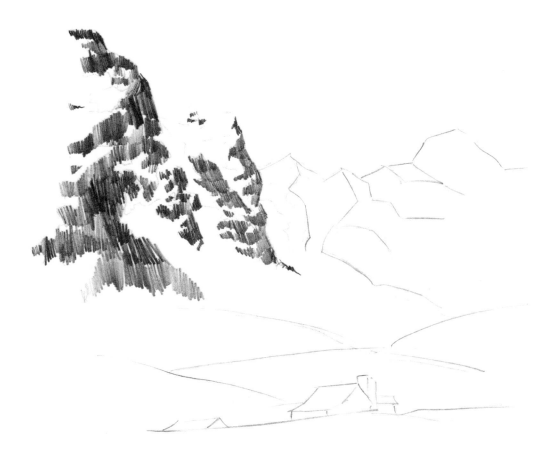

Step 1.

First, I sketch in the basic outline with a 4H pencil. With the values clear in my mind, I put in the darker middle tones of the mountain with an HB pencil. By placing only the darks, I can simplify the patterns that are created by the melted snow. This pattern can become very confusing, so I try not to see too much. By squinting your eyes, many of the small value changes will disappear.

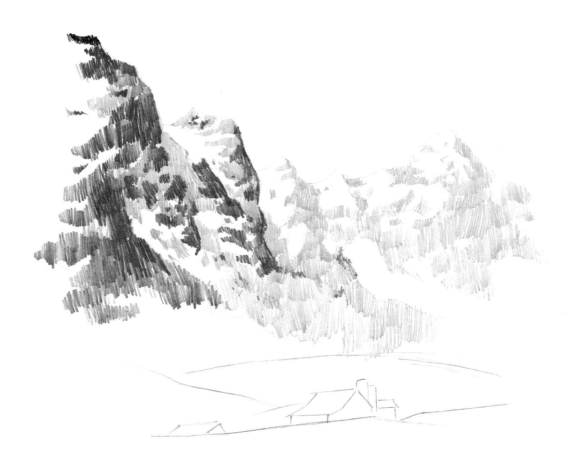

Step 2.
Using a 4H pencil, I render the dark side of the light mountains the same way I did the middle tone mountains. The white of the paper will hold the areas of the snow in these mountains. With the same pencil, I indicate the lighter tones in the dark mountain. This softens the tonal difference between the dark of the mountains and the white snow.

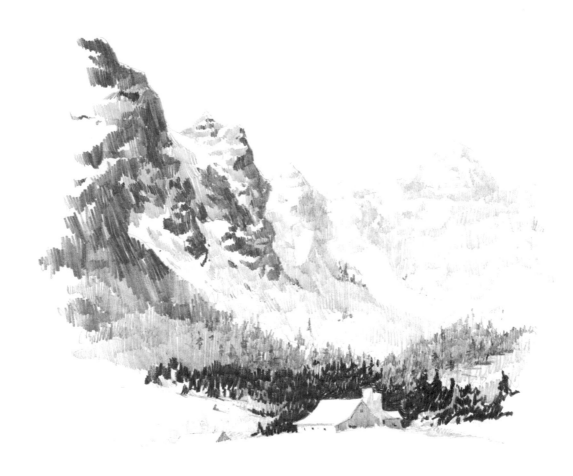

Step 3.
Once the background mountains are established, I put in the darkest tones in the drawing with a 2B pencil. This will connect the mountain area and the foreground and also give me a sharp silhouette of the farm. Using a 2H pencil, I bring the remainder of the mountain down to this dark area. I add as much detail as necessary to create the feeling of trees. The shadow side of the barn is put in with a 4H pencil with very little detail.

A

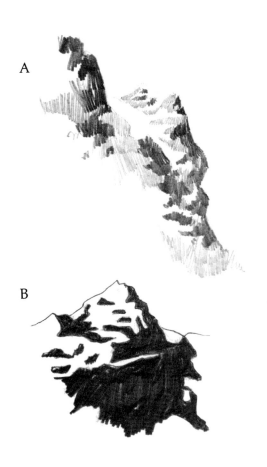

B

C

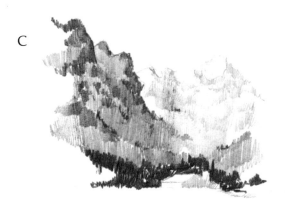

D

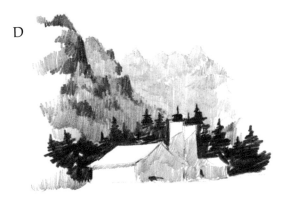

Details of the Mountain

A. The darker mountains are indicated using two pencils and three values. The dark area of rocks is drawn with an HB pencil. Notice how the strokes are mostly vertical but occasionally go in different directions. The middle tone area is drawn with a 4H pencil using the same type of strokes as I used in the darker area. This is the shadow area of the snow. The third value is the white paper, which has no tone.

B. A simplified diagram of the tonal pattern of the light mountains.

C. Notice the different feel you get when you change the size of the farm in the foreground. The mountains seem to tower over a small farm nestled in the foothills.

D. The mountains become a background for the large farm. Changing the size of the objects in a landscape can change the entire atmosphere of the scene.

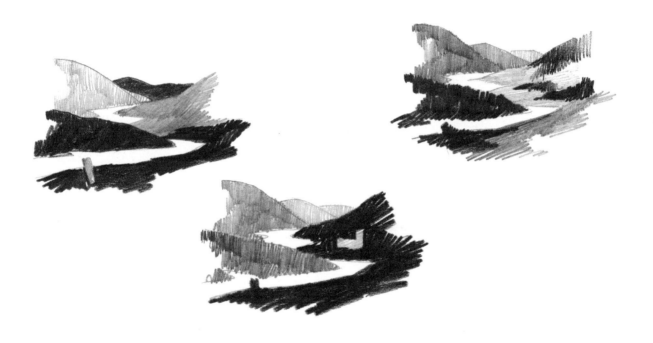

Preliminary Value Studies

Since there will be more than three values in this drawing, I do several value sketches first. I want to get the feeling of the low rolling hills, and I also want a device to move my eye into the picture. My first reaction is to leave the river white as a means to move my eye. I like this and stay with it through the remainder of the sketches. To get the most effective sense of distance, I keep all my darks in the foreground and use lighter values as the hills recede into the background. The first sketch loses its effect when I make the hill in the distance dark. Next, I make a sketch with the right side dark hoping that the barn will stand out and the light will come from the right. I discard this because the drawing looks too heavy on the right side, resulting in poor balance. I finally arrive at the last sketch with the darks in the foreground and the hills becoming lighter in value as they go into the distance.

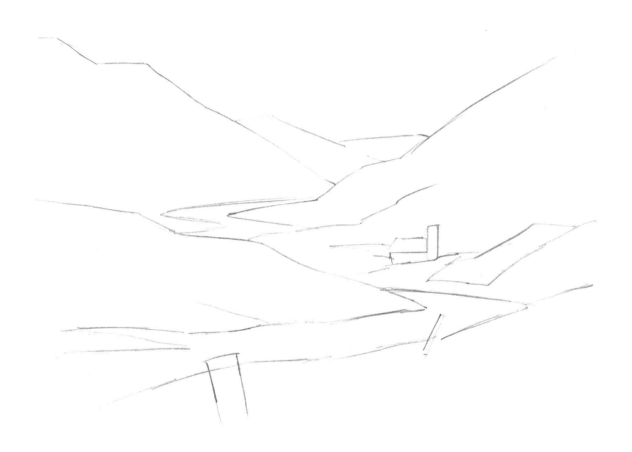

Step 1.
Since I am satisfied with this arrangement, I proceed to lay-in the drawing with a 4H pencil.

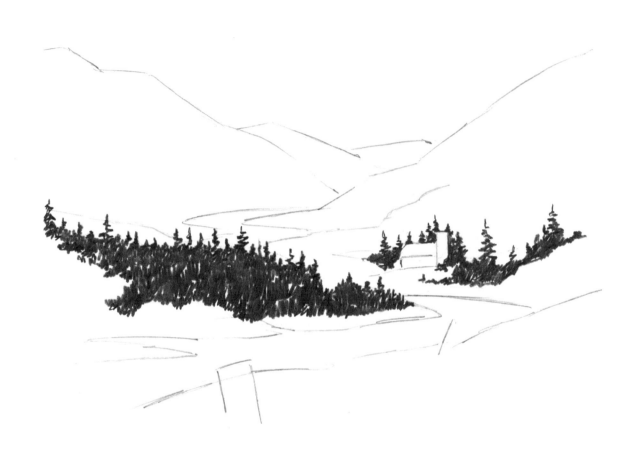

Step 2.
With a 2B pencil, I place all the darkest values. I am also careful to silhouette the barn. Although this is a small area, it is very important in turning the direction of the eye back into the picture.

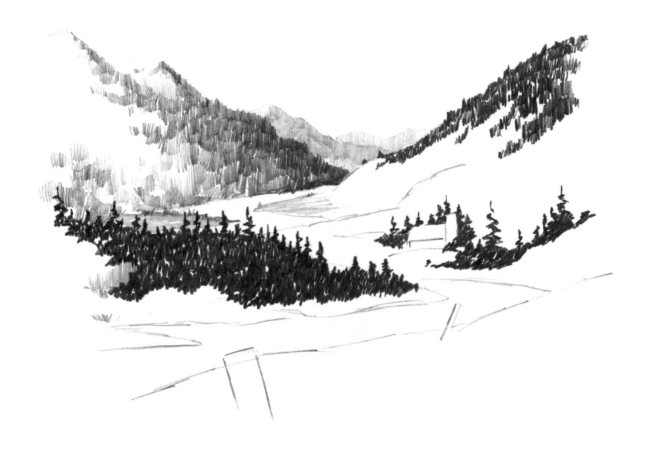

Step 3.
I put in the background hills using a 2H, 4H, and 6H pencil as the hills recede into the distance. There is very little detail in these hills since I want them to be simple shapes.

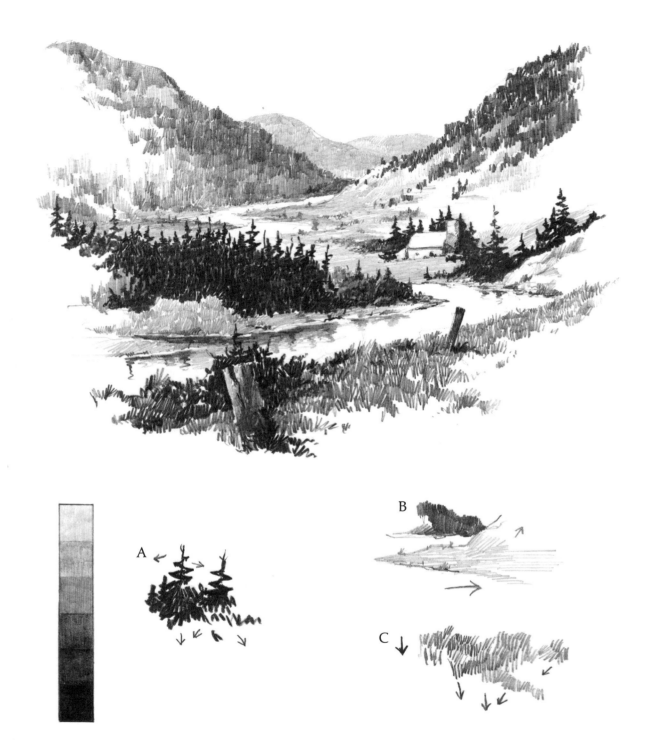

Step 4.

I indicate the middle tones in the lowlands using a 4H pencil. I use only enough tone for the river to stand out. I then put in the details of the foreground with an HB pencil showing the pattern of grass to create interest in this area. I arrive at the six values in this finished drawing, not including the white paper. Although there are more values here than I recommend you use, I do try to keep each value in a simple area.

Details of the Hill

A. To draw these fir trees, I put in the main trunk first and then move from side to side with short strokes to indicate the branches.

B. The feeling of flatness is achieved in the lowlands by using horizontal strokes.

C. The grass is rendered with short strokes going in different directions.

Step 1.

I lay-in the outline drawing with a 4H pencil. My main concerns are the direction of light and the angular shapes of the rocks. Since most of the drawing will take place in the rendering, I indicate a minimum amount of detail. With an HB pencil, I put in the shadow areas of the rocks, making sure this section does not become solid black. Therefore, I leave small spots of white between the lines, which gives me a little more life in the dark area. Also, I make sure to leave the branches of the foreground tree white where they fall across the dark areas.

Step 2.
The middle tone of the rocks is indicated with a 2H pencil. The short strokes follow the form of the rocks. Using small strokes that vary in value and direction, I draw in rocks that are broken and jagged. I use longer even lines for rocks that are smooth. Make sure to see the character of the rocks you draw.

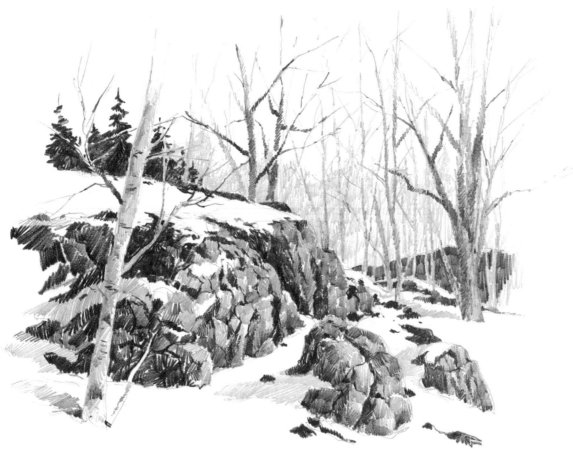

Step 3.

I draw the background hill with a 2H pencil, leaving the tree white. With a 6H pencil, I lay in the light tone in the background, the tree in the foreground, and the shadows on the snow. The distant trees are then drawn with a 4H pencil. No outline is used to indicate these trees. I finally accent small dark rocks with a 2B pencil.

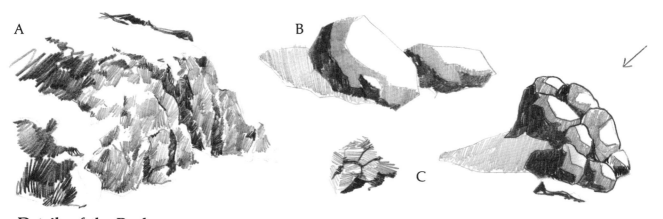

Details of the Rock

A. Here are the halftone lines that follow the form of the rocks. In this particular type of rock, there are many small planes If you the light at different angles. When this happens there is a small value change. Rather than indicate each of these changes, the same effect can be achieved by changing the direction of the strokes.

B. All rocks have a light side, middle tone, and dark side. When the rocks are smooth and flat, be sure there is a value change between a rectangular areas.

C. Some rocks have many cracks and crags. Each of these small sections picks up the light and has a light, middle, and dark side. However, care should be taken that the rock does not become too complicated. The rocks in the demonstration had many cracks, so I drew them using only two values—a middle tone and a dark tone. By doing this, I have simplified what could have been a very confusing drawing.

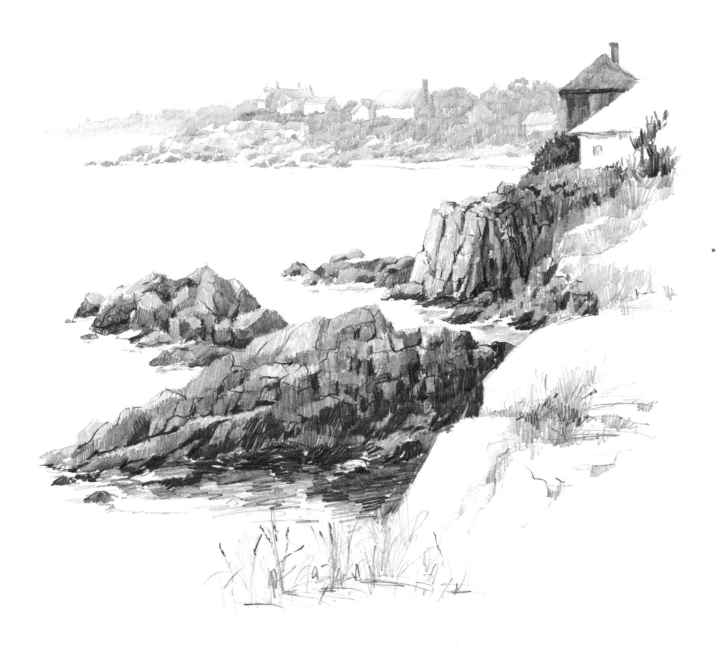

JAGGED COAST

Rocks on the New England coast are dark and jagged as compared with rocks in other areas of the country. Take as much time studying them as you would a tree, house, or boat. I want to capture the feeling of the many fingers of rocks that protrude out into the ocean along the Massachusetts coast. To do this, I look for a spot where I can see down the coastline. For the feeling of distance, I keep the farthest rock a light value with a 4H pencil. As I come closer to the house on the right, I use a darker value with a 2H pencil. The foreground rocks are the darkest and all of the detail is put in this area. With HB and 2B pencils I draw the rocks with short strokes following the form of the rocks. There is only a slight indication of the water around the base of the rocks. I do not play this up too much, since I want the interest to stay in the rocks.

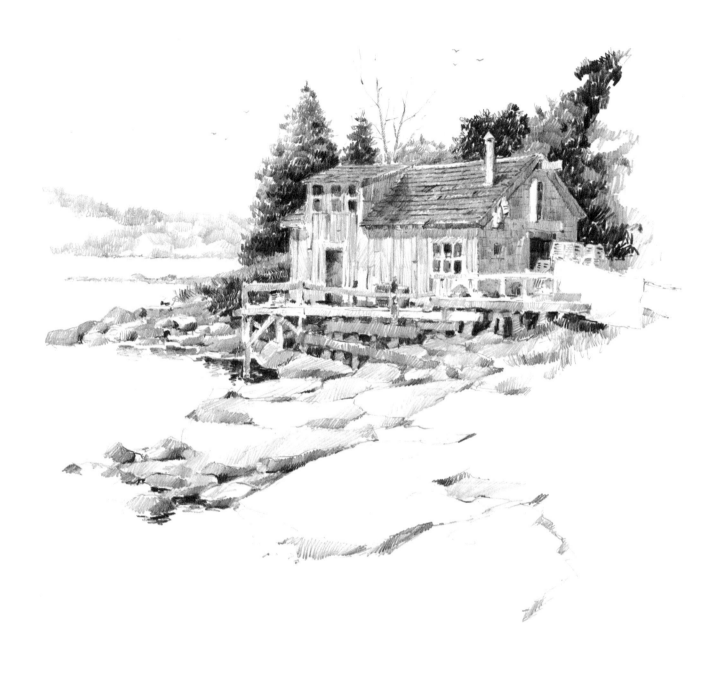

QUIET COVE

This drawing is an example of another type of rock found in the New England area. The long, flat, smooth rocks can make a great device for moving the viewer's eye into the picture. I indicate the dark trees in the background with HB and 2B pencils and the lobster shack in a middle tone with 4H and 2H pencils. The foreground rocks are drawn with a 4H pencil. I make sure to leave many white areas on the tops of the rocks. With 2H and HB pencils, I put in the dark cracks, carefully placing them so there will be a strong movement of the eye up to the shack. I do as much rendering in the shack as I feel is necessary to convey the character of the building. These shacks are typical of New England lobster areas.

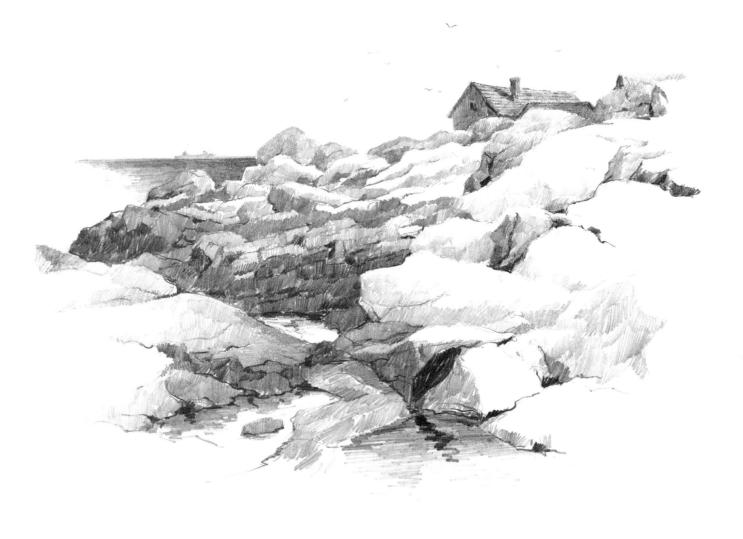

THE PUDDLE

Sometimes a small, insignificant spot can create a little interest, which was the case as I was drawing the rocks. This small puddle made a light spot in the dark areas of the rocks. I first make a careful drawing of the rocks and background with a 4H pencil. I follow with all the dark areas of the rocks using HB and 2B pencils. In some of the very dark crevices, I use a 4B pencil. The background area I indicate with 4H and 2H pencils, with only a slight amount of detail. I leave the spot of water white and put the reflection in with a 2H pencil.

Industrial Scenes, Houses, and Cityscapes

Although they differ in subject matter, industrial scenes, houses, and cityscapes have common problems when you attempt to draw them. Industrial and city scenes often have a great deal of activity going on: new constructions, modern buildings, people, etc. You should be careful about how much you want to include in your drawing.

When drawing houses and buildings, it is necessary to understand their basic shapes. Most con-structions are a simple rectangle with small sections added such as, sheds, porches, extra rooms, dormers, etc. In order to indicate form and lighting, it is necessary to understand how these sections fit together.

In this chapter, I will show you the preliminary value studies of industrial scenes, followed by step-by-step demonstrations of industrial scenes, houses, and cityscapes with detail drawings.

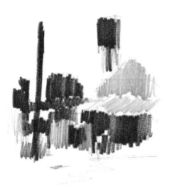 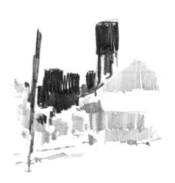 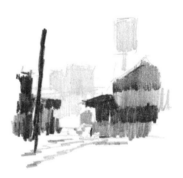

Preliminary Value Studies

For this demonstration I must make several decisions before I start to draw. As I look at the scene, all the buildings, including the tower, are dark in value and on the same plane. Darks are every-where: the tower, the tanks in the background, the tank car, and the shadows under the loading plat-form. I make several sketches first to simplify the patterns.

In the first sketch, I leave the values as they appear and try to work out some separation between the areas. This does not work well because there is no depth to the picture and no areas for my eye to roam around. In the second sketch I leave the tanks in the background dark, and keep my lights and middle value in the foreground. This could work, but I feel this restricts my values and I cannot put some nice darks in the foreground. In the third sketch, I keep the background light in value and the darks and middle tones concentrated in the fore-ground plane. Here I have the depth that I want, my eye leads into the picture between the darks, and I have a chance to put detail in the foreground.

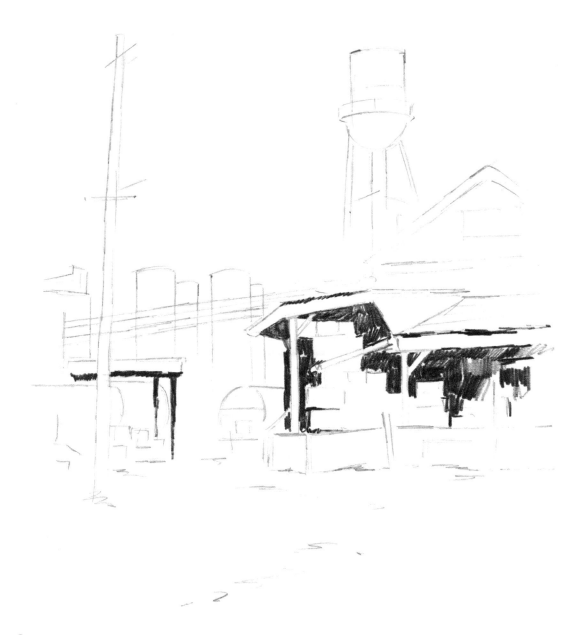

Step 1.

Once I decide my value arrangement, I sketch in the complete scene with a 4H pencil. There are several key spots I want to establish. The location of the water tower on top and the pole on the left are put in to define the upper and left extremities. The placement of the tank car is important because it is the center of interest. When I am satisfied with the perspective and positioning of the major areas, I be-

gin adding the values.

With a 2B pencil, the first value I lay-in is the dark shadow on the right side, under the loading platform. I change the direction of the strokes and leave small spots of white so that the area does not become solid. With the same 2B pencil, I add darks to the building on the left.

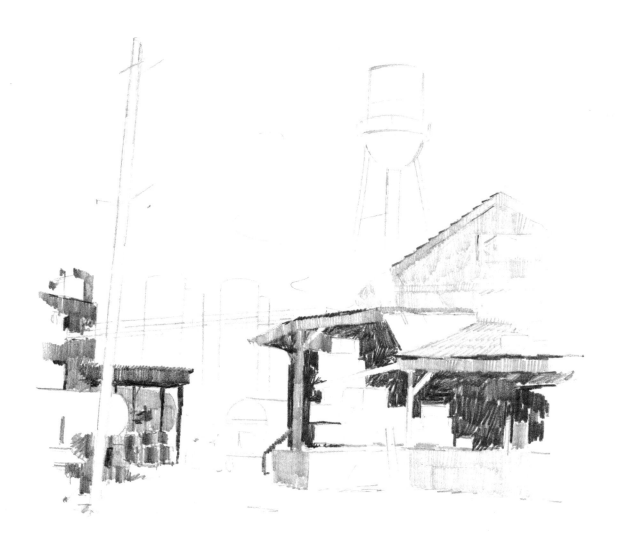

Step 2.
I indicate the upper part of the building on the right with a 4H pencil. Again, I change directions of the strokes to keep the lines from looking the same. I decide on a vignette, so I am very careful not to create a sharp "cutout" look on the right side. I move over to the left and indicate this building with an HB pencil for the dark areas and a 2H pencil for the lighter tones.

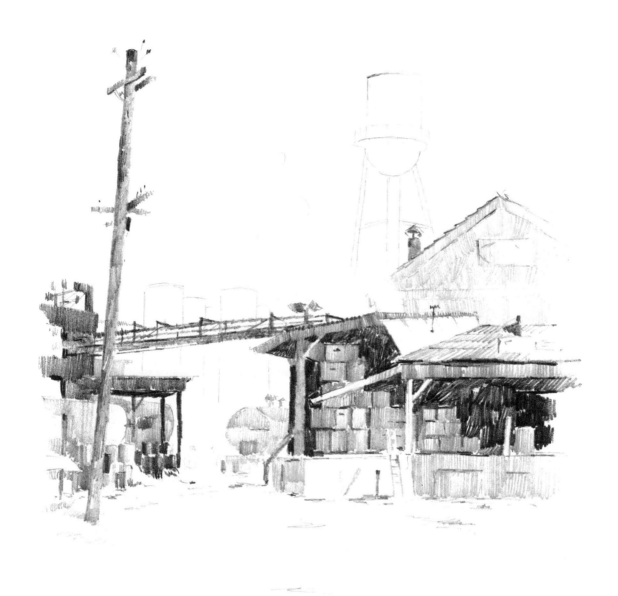

Step 3.

Using a 2H pencil, I finish the area under the shed on the right. I use a vertical stroke, pressing a little harder where I want to create form in the crates. Accents between the crates are put in with an HB pencil. The telephone pole is indicated using a 2H pencil and the accents with an HB pencil. I draw in the tank car with a 2H pencil, and I add the pipelines that run from the left building to the large right building with an HB pencil. The front plane, with its dark and middle tones, is now complete, so I proceed to the background.

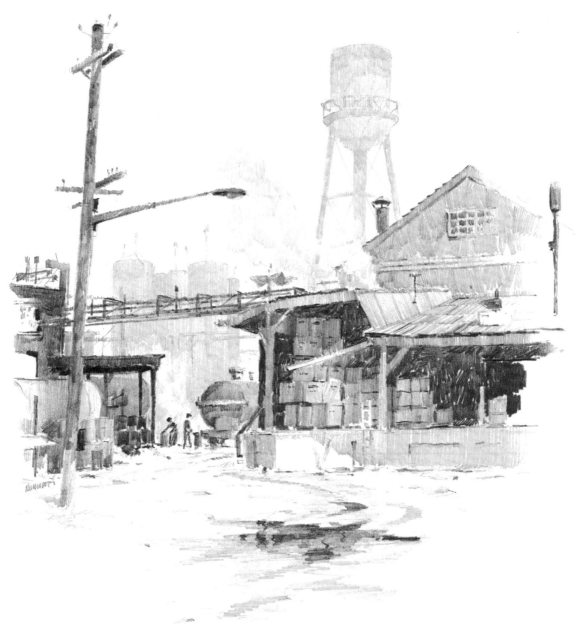

Step 4.

With a 6H pencil, I lay-in the water tank and the oil tanks in the distance. While drawing the tank, I vary the pressure on the pencil to give a slight indication of form.

As I look at the drawing, I notice there is not enough separation between the values of the building on the right and the water tank. I take a 2H pencil and darken the building one value to "push" the water tank into the background.

I put the foreground in with a 2H pencil and the darker accents with an HB pencil, making the lines horizontal to give the feeling of flatness. I make sure the direction of the foreground leads my eye to the center of interest.

When the drawing is complete I find there are several elements I want to add to make the composition better. I put two small figures in the center of interest, add a light on the telephone pole to eliminate the "hole" in the center of the picture, and add a light stanchion on the right, which creates the vertical line I need to contain the right-hand side of the drawing.

Step 1.

The first line I put in is the angle of the roof on the right with a 4H pencil. I note where the roof of the main section meets this area. With the 4H pencil, I then sketch in the rest of the main section. Before indicating any of the detail, I make sure the proportions between the height and width are correct. Once I have checked the proportions and place- ment, I proceed to lay-in the first tones. I start with the roof with a 2H pencil, using short strokes that follow the direction of the shingles. At various places I change the direction of the strokes to break up the monotony. With an HB pencil I put in horizontal lines to indicate the row of shingles.

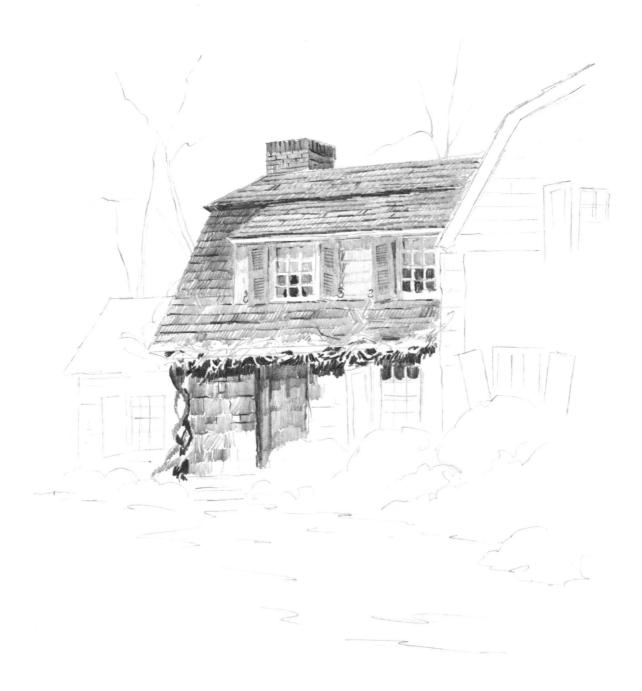

Step 2.

I finish the roof, rendering as many shingles as I think are necessary. It needs a dark tone above the dormer, so I use a 2B pencil to indicate this line. Using a 2H pencil, I put in a chimney on the light side and an HB pencil for the shadow side. Accents are put in with an HB and a 2B pencil. To finish the dormer windows, I use a 2H pencil and a 4H pencil on the shutters. I very carefully go around the vines on the edge of the roof. Under the eaves, I put in the shadow with a 2B pencil, leaving white areas for the vines. Then I lay-in the facing stones with a 2H pencil, changing the pressure and direction to give a variation to the values and texture. The door and the vines on the left are put in with a 2H pencil and the accents with a 2B pencil.

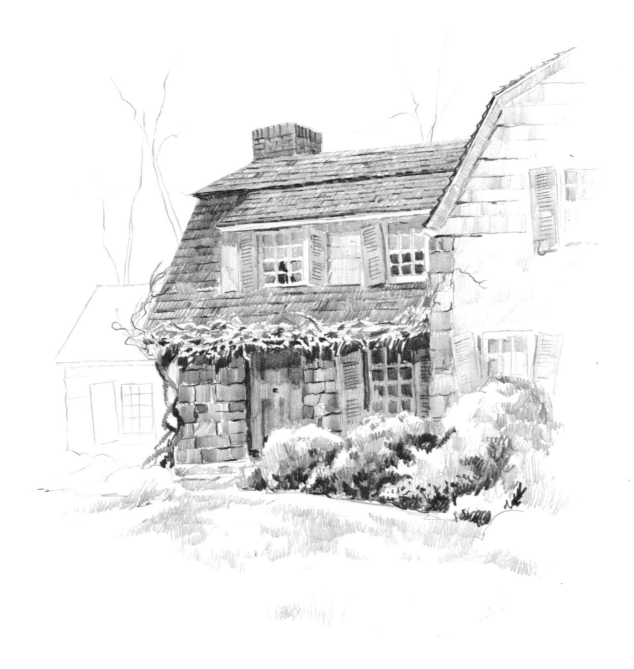

Step 3.

To complete the main part of the house, I use the 2H and HB pencils. I accent the edge of the roof on the right side with a 2B pencil. All the upper shingles are put in with a 4H pencil, varying the pressure. Rather than draw in all the windows, I decide to let the windows fade off in order to give me a better vignette effect on this edge. For the stone-work in the lower section of the right side, I use a 2H pencil. For the very light indication of the remainder of this section, I use a 6H pencil. In the foreground, I put the grass in with a 4H pencil using short vertical strokes. The shrubs are a combination of short strokes using a 2H, HB, and 2B pencil for the light, middle, and dark tones.

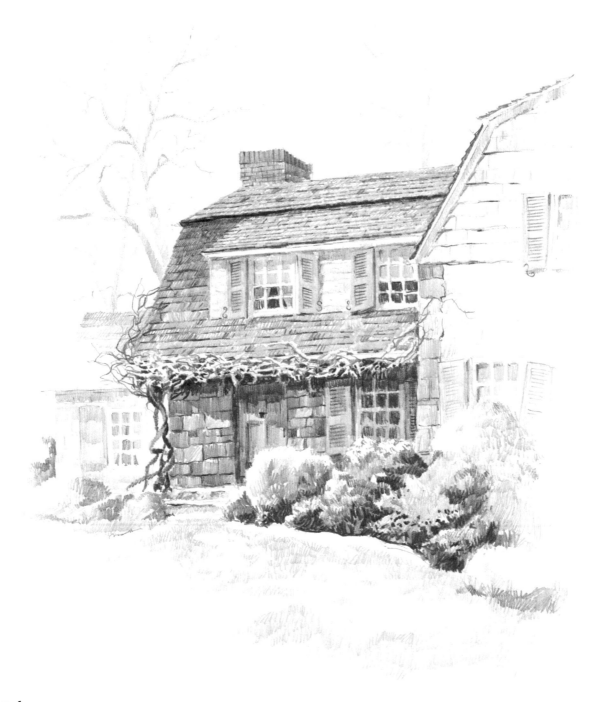

Step 4.
I then complete the trees and the small extension on the left with a 6H pencil. Using a 4H pencil, I add the accents to this area. I finish the drawing with a few accents in the windows, below the vines, and under the shrubs with a 4B pencil.

Step 1.

The accuracy of the lay-in drawing is very important. In all cityscapes, perspective must be closely observed. Even though I did not accurately make the vanishing points, I was very aware of all perspective lines going to my eye level. Since I want to show the effect of height, I use a low eye level. I indicate all the major branches on the tree because it will be a light tree against dark and middle tones. After I lay-in the drawing with a 4H pencil, I indicate tall background buildings with a 6H pencil. I do not press hard, so I can obtain a slight variation of tone. Before I finish the light area, I put in the dark area on the left side with a 2B pencil. I want to make sure there is enough separation between the dark value and the light buildings in the background.

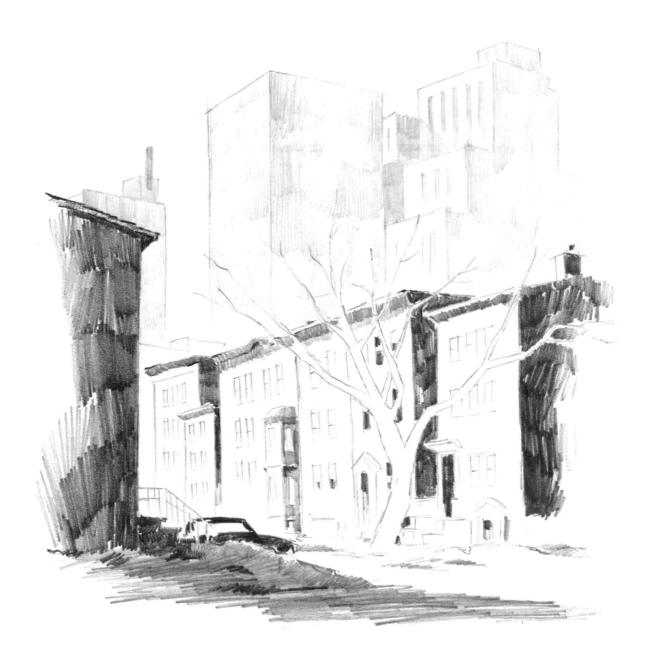

Step 2.
I put in all the shadow areas of the houses and finish the building on the left with a 2B pencil. With a 2H pencil I draw in the foreground area and the shadows under the eaves. By rendering only the dark areas, I am able to see the value pattern of the drawing. The small darks on the right balance the larger dark building on the left.

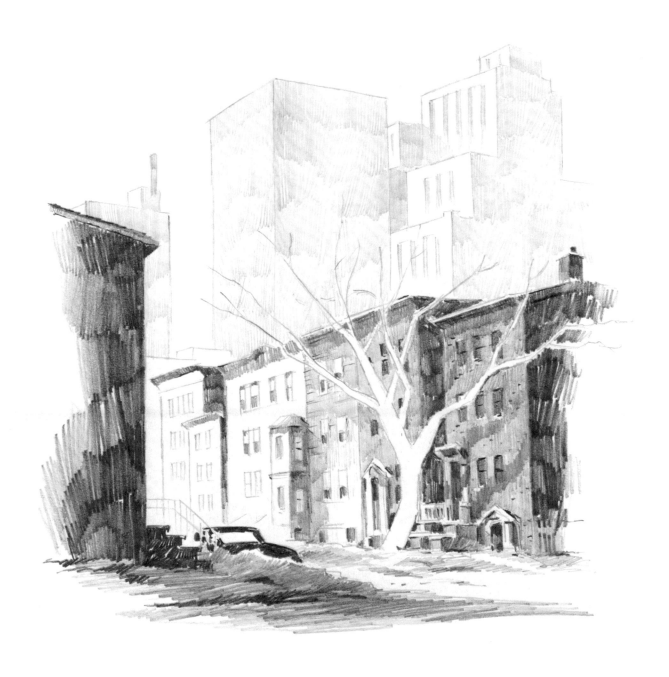

Step 3.

Starting with the houses on the right, I put in the middle tone with a 2H pencil. The light is coming from the left, so I want these houses to become lighter in value as they reach the large dark mass on the left. With the values darker on the right, I can also make the tree stand out. The windows are indicated with an HB pencil and the steps and car with a 4B pencil.

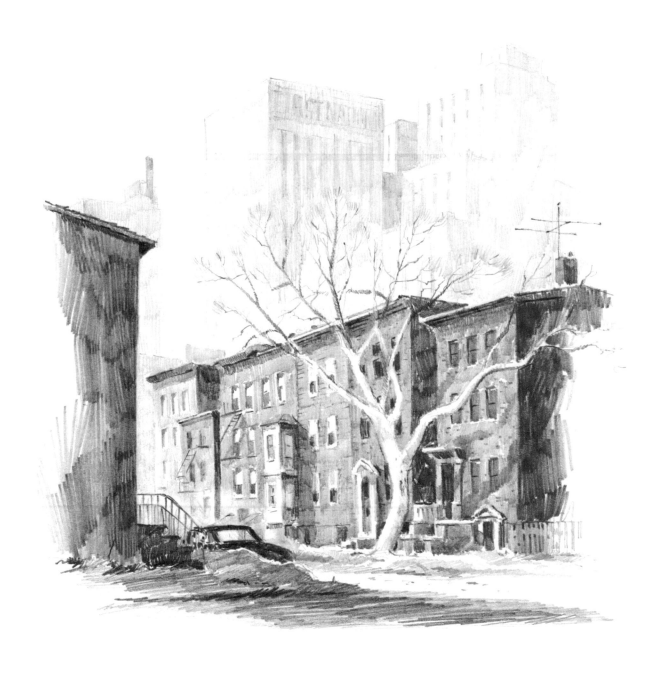

Step 4.
To complete the front of the houses, I use a 4H pencil. I indicate the tree with very little modeling with a 4H pencil. I finish the drawing with an HB pencil by placing small accents in the windows, railing, doors, TV antenna, and tree.

B

A

C

Details of the Cityscape

A. A large vignetted area can become very cut-out looking if it is not rendered with a little planning. Avoid a sharp edge. Keep a change in the direction, the length, and the value of the strokes.

B. Do not outline the windows and then fill in with a tone. Let the tone around the window hold the shape even if it is ragged, then add the darks of the window itself.

C. Edges of the trees can be softened with a few small strokes feathering around the small branches.

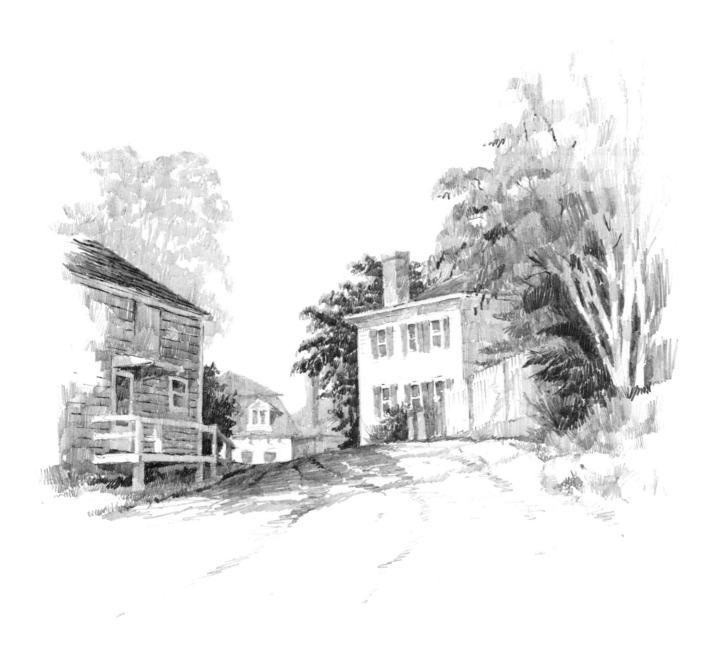

JEWETT STREET

On many of the streets in old towns and villages, the streets are not level and the houses are at different angles. This can cause a bit of a problem with perspective, and a careful lay-in drawing must be made. Although it is not necessary to draw eye levels, vanishing points, and perpendiculars, a thorough knowledge of these principles must be observed. In this drawing of Jewett Street, I decide to sit on the side so the road will not be even on both sides. I keep the buildings light at the end of the street so that they look like they are on a different plane. I put the darks in on the right with an HB pencil and use a 2B to spot the darker areas.

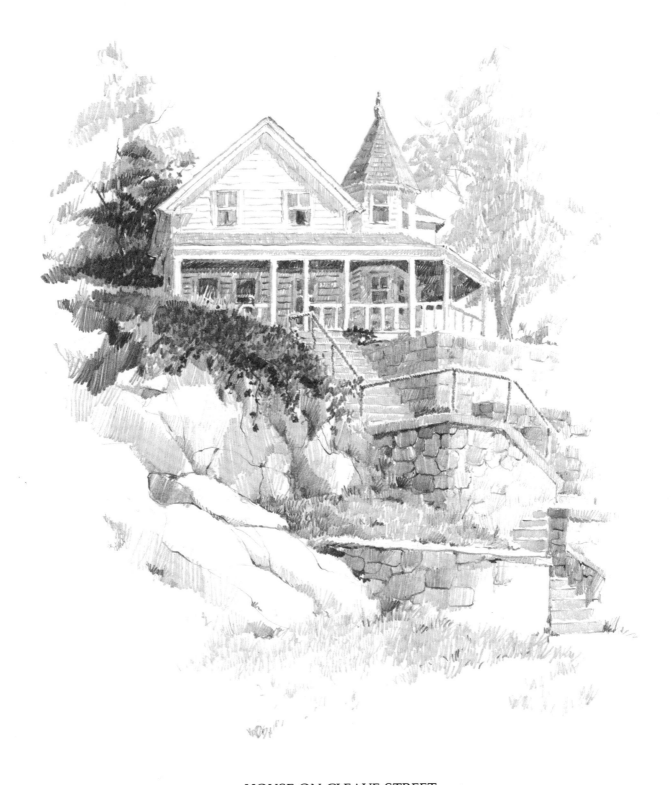

HOUSE ON CLEAVE STREET

Since this house sits high above my eye level, it is difficult to draw. Not only was the perspective difficult, but the house itself has so many angles and additions that I have to make a very careful lay-in drawing. I chose a time of day when the shadows under the porch would render some dark values in the house.

First, I indicate the background trees with a 2H pencil and completely silhouette the house. The large rocks and the steps in the foreground are put in with 2H, HB, and 2B pencils. I keep the steps light so there is a nice path for the viewer's eye to travel up to the house. When all of these areas are complete, I finish the values in the house. I leave the house until last so that it will not become too dark with detail. I always have the background and foreground values for comparison.

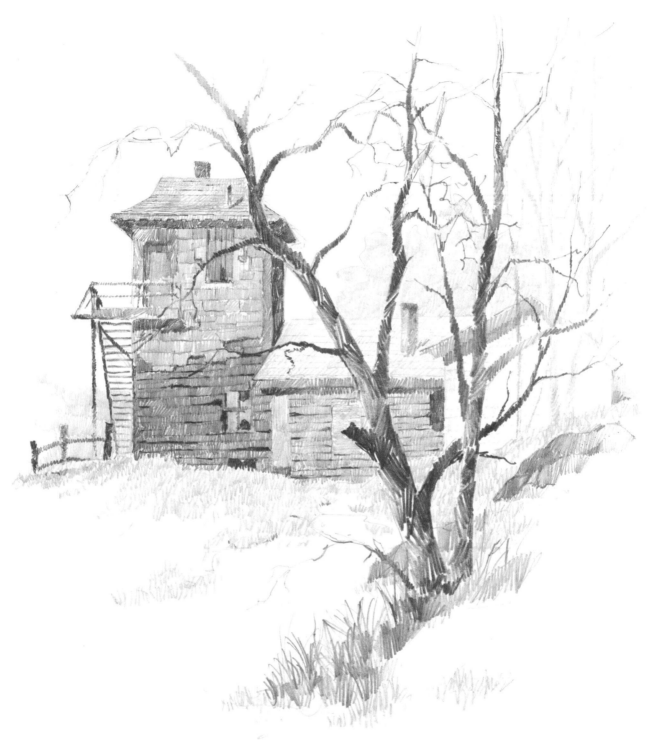

ABANDONED STATION

Old buildings always have a nice variety of textures, as was the case in this old train station. I never know how long these buildings will be around, so I like to make drawings of them while they are still here. I start with the main part of the station first, after lay-ing-in the drawing with a 4H pencil. I achieve the various textures with 2H and HB pencils using short strokes. Keep in mind that the more texture you put in an area, the darker the value of that area becomes. This is why most of the time I lay-in the back-ground first. However, in this drawing the background is white, so the value is not as critical in the station area. The dark trees give me a nice vertical movement. I draw the trees with an HB pencil and the snow and shadows are put in with a 4H pencil.

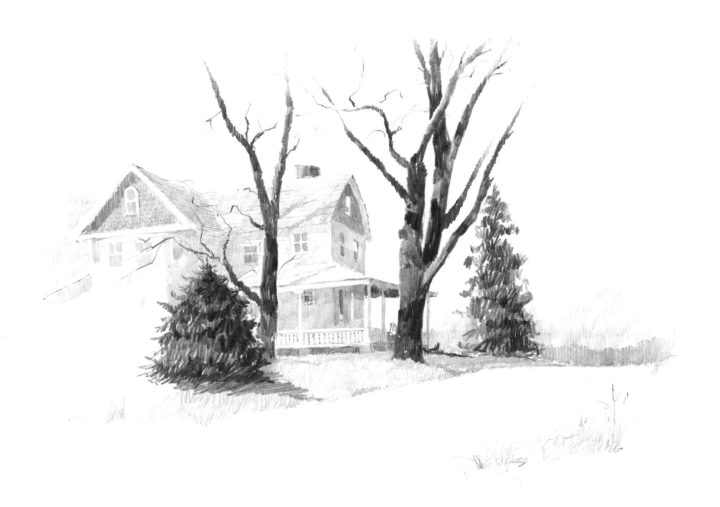

DEAD TREES

It is difficult to make a formal composition interesting. In this drawing, I have two trees on the left, balanced by two trees on the right, with the house in the middle. I try to make this balanced composition interesting by the vignetting. After the lay-in drawing, I render the trees with an HB pencil. The dark accents are indicated with a 2B pencil. I then draw the house with 4H and 2H pencils. I complete this quick drawing in about a half hour.

Boats, Harbors, and Reflections

Aside from "pure" landscape drawing, the harbor and shore area offers the artist many possibilities for subject matter. Ships and boats have their own particular characteristics in each part of the country. Be sure the detail is accurate in your drawing. My gallery is located in the New England fishing village of Rockport, Massachusetts, where the local fishermen always come in to look at my work. If I have placed a mast, sail, or deck house in the wrong place, I am soon told about it.

In this chapter, I will show you how to render boats and harbors in two step-by-step demonstrations with detail drawings. The last section on "Reflections" will not be done in step-by-step demonstration form. Each drawing will show how to indicate different types of water reflections.

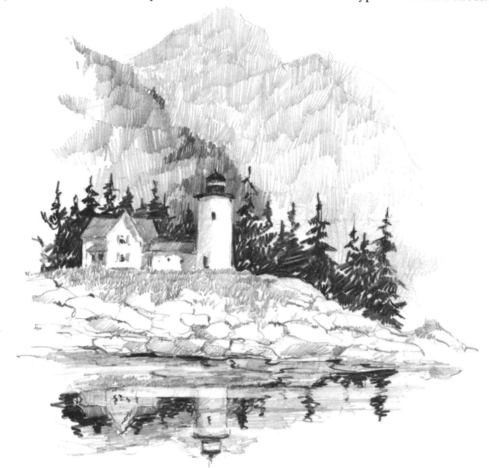

ROCKY SENTINEL

This quick sketch of a lighthouse had a simple pattern of lights and darks that interested me. Most of the time lighthouses stand out on the end of rocks with very little shrubbery around them. It is difficult to get a wide range of values when there are no dark trees as a background. Therefore, I frequently take artist's license and put trees behind a lighthouse. In this scene they are already there so the values are made-to-order. With a 2B pencil I lay-in the large mass of dark trees. I then put in the foreground rocks and water with 2H and 4H pencils. With a minimum of detail, I indicate the detail in the lighthouse.

Step 1.

In most harbors the bulkheads and piers are very dark, which gives you a good opportunity to silhouette the light boats against a dark background. That was the case in this situation. The "dragger" was tied up at the end of a pier that had very dark under pilings. I sketch the drawing in with a 4H pencil. Accuracy is important. I make sure the relationship between the deckhouse and the hull is cor-

rect. I measure the distance between the deckhouse and the bow, the height of the mast to the length of the boat, the dinghy's size, etc. Once you determine how long the boat is, it is easy to measure the height of the mast against it.

The first value I lay-in is the darkest. I start with a 2B pencil and draw the dark area of the pier, which gives me a complete silhouette of the boat.

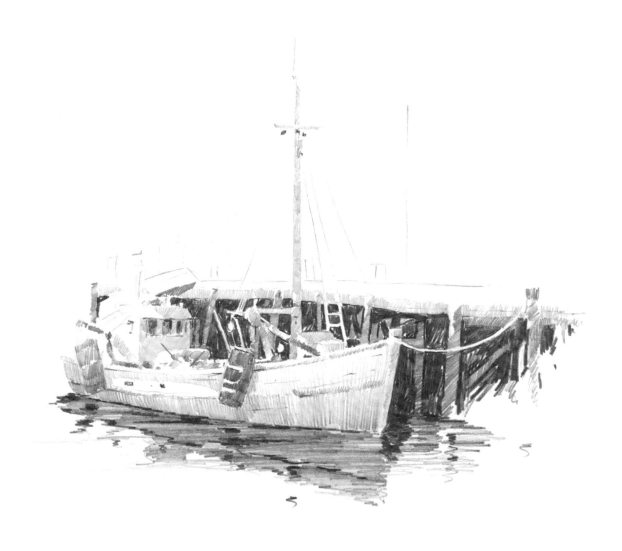

Step 2.
With a 2H pencil, I darken all the pilings under the pier. Then, using a 4H pencil, I lay in the mast (no outline), the shadow side of the deckhouse, and the hull. The pencil strokes on the hull follow the form of the hull. I take a 2H pencil and darken the lower portion of the hull, going right over the 4H pencil lines. With an HB pencil I indicate the windows, the underside of the small boat, the pallets (the platforms hanging over the sides of the boat), and the water. The reflection is drawn with horizontal strokes to make the water lay flat.

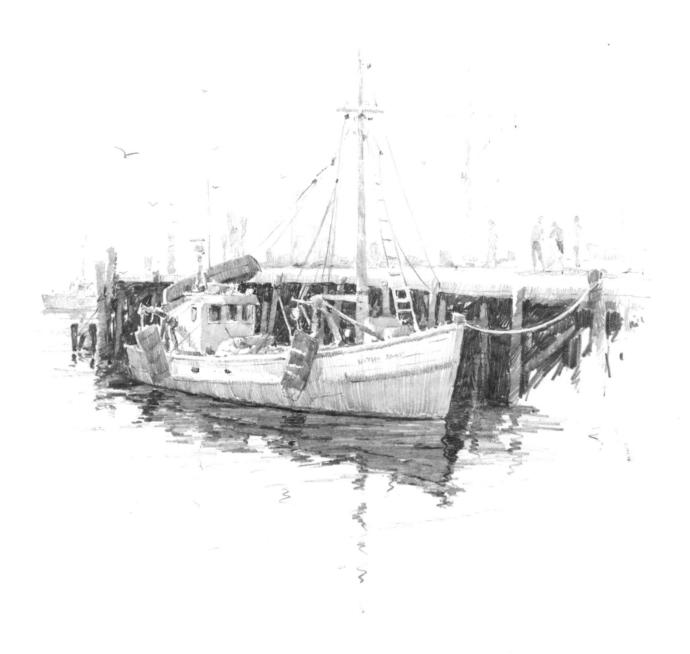

Step 3.

I then draw in the background with a 4H pencil. A slight indication of dock pilings, masts, and figures is enough to give me atmosphere and depth.

The pier stops just in back of the deckhouse and I find this a disturbing element. I thought the darkened stern of the boat would be strong enough to hold a shape against the light. It does not work, so I take a 2B and 2H pencil and extend the pier in back of the boat. I add several low pilings so it is not such a sharp edge. For more interest and depth, I add another fishing boat in the background. This makes a better balance to the drawing. I indicate gulls in the sky to create a little movement and break up the water with a few horizontal strokes.

Detail Studies of Boats

A

A. There are a few easily noted features common to all ships and boats. If you understand and look for these points, you will be able to draw a more convincing boat. For instance, the bow of a ship is either raked or straight. There may be variations in the angle of the rake, but they are all basically the same. Sheer is a very important item. It is a curve or sag a little aft of the center of the length. Without it any drawing of a boat will look flat and shapeless. Freeboard is the height of the side above the waterline. The character of the boat is often determined by how high some boats float above the water and how low others sink into the water.

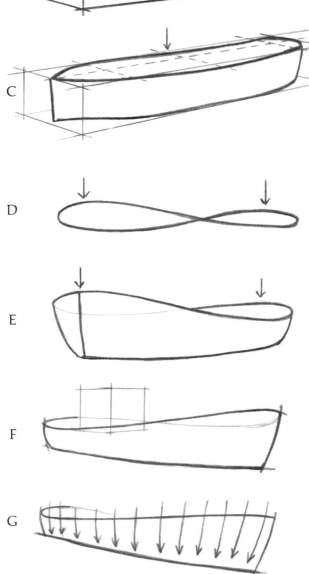

B. Perspective enters into the drawing because a boat is very much like an oblong block of wood before the ends are shaped. If you don't allow for perspective, here is the effect you'll get.

C. In this drawing all perspective lines end at two vanishing points on my eye level. I then place a center line going fore and aft to fix the stem and the stern. Notice, as you draw the ship in perspective, how the sheer gives a curve to the upper edge of the boat. This becomes more noticeable as your eye level lowers.

D. The most common view of a boat is from slightly above and at an angle. Because of the sheer, the top edge of the hull becomes an elongated figure-eight.

E. The highest points of the figure-eight are the location of the stem and stern. How far from the ends of the figure-eight these points are located, depends upon the angle from which you are looking at the boat.

F. A diagram of the boat used in the demonstration is drawn in the same manner. I place a cube in the hull to show how the deck house fits in the boat.

G. When rendering the sides of the boat, you should follow the rounded form of the hull. The lines will follow the same direction as the ribs in the old wooden boats.

DEMONSTRATION 2. HARBORS

Step 1.

Simplify the harbor scene. If there are 200 boats in the harbor, don't try to indicate 199 of them. Select a few that make an interesting pattern and leave out the rest. It is also a good idea to draw a moveable object first. There is nothing more frustrating than to be half-finished with a harbor scene drawing and have the boats leave. The shacks, docks, and trees will always be around, but the fishermen have a habit of moving their boats at the wrong time.

In this harbor scene, an early morning fog has set in, so I decide to keep all my darks in the foreground, with a white sky and water and middle tones in the distant shore. I lay-in the entire scene with a 4H pencil, leaving out many boats that were moored in the harbor. With a 6H pencil, I indicate the distant shoreline leaving the tall fir trees as a silhouette. I lighten the pressure on the pencil as I move to the waterline to give a graded value to this area. To indicate the trees, I use short strokes, and make a few darker so that you are able to recognize what they are. I render the shadow side of the shacks in the distance with a 4H pencil. The window and the darks under the shacks are spotted with a 2H pencil. Notice that the value range in this area is from 9 to 7, using a 6H pencil to a 2H pencil.

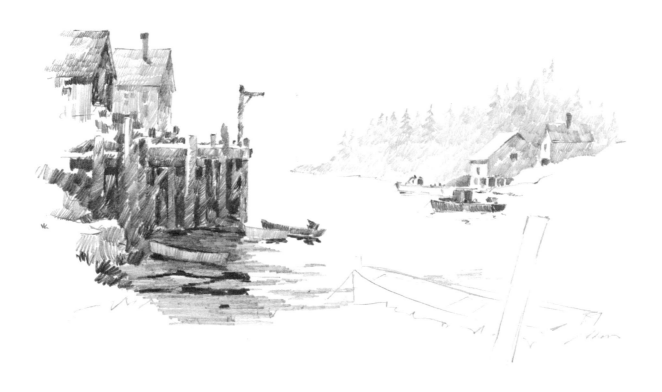

Step 2.

I move to the left and indicate all the darks with a 2B pencil. This includes the dark house, the space between the poles in the pier, and the reflection in the water. Using an HB pencil, I put in all the middle tones of the pier. With the same pencil, I put in the foreground mud using horizontal strokes. I apply more pressure closer to the base of the pièr, so the base of the pole will blend with the mud. The roof and the side of the left shack are rendered with a 2H pencil. I draw the other shack and the boats with a 2H pencil. The strokes on the boats are vertical, following the shape of the hull. The range of values in this area are from 7 to 4, using 2H to 2B pencils.

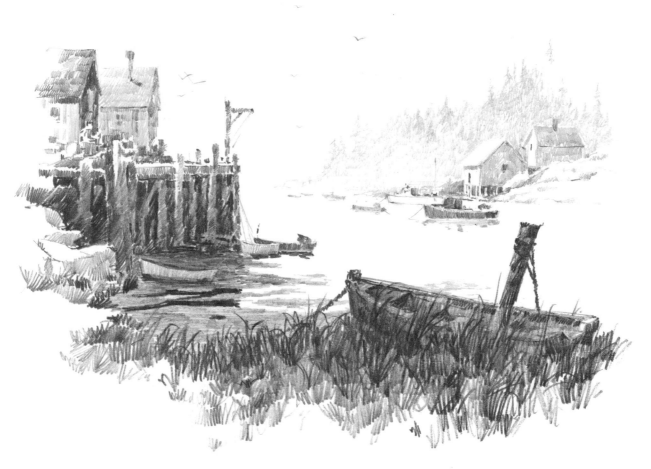

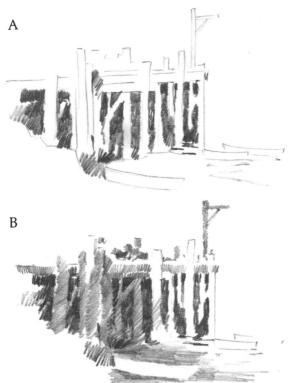

A

B

Step 3.

The foreground grass and boat are drawn in with an HB and a 4B pencil. I want this area to be dark with little detail. I add the rope from the pole to the boat, so the pole does not "lean out" of the drawing. Then I place gulls in the sky with a 2H pencil. The values in the foreground are from 4 to 1, using HB to 4B pencils.

Details of the Harbor

A. The area under the pier can become very confusing. If the value difference of the poles and the darks between them is not too great, the pier will hold together as a unit. I put in all the darks first with a 2B pencil. The strokes are short and occasionally change direction. It is not necessary to have sharp edges on the poles—let the edges be ragged.

B. Once all the darks are indicated, I fill in the poles with an HB pencil. These lines go right over the darks I put in with the 2B pencil. Keep this area loose; don't have sharp edges or wide value changes.

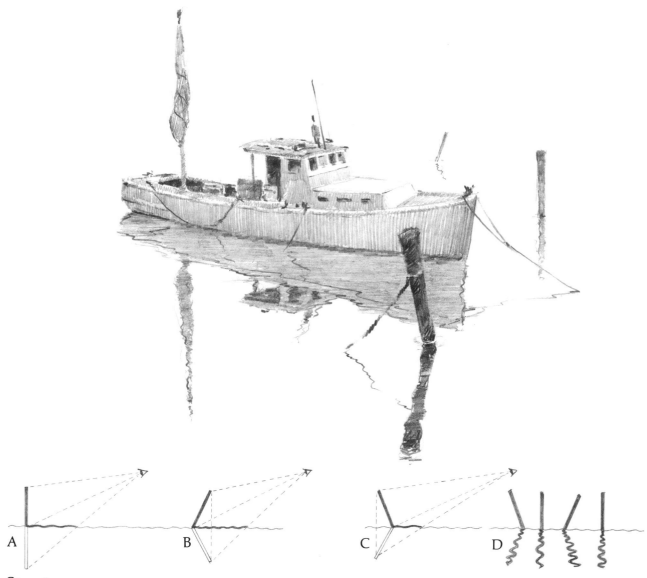

Step 1.

In an enclosed harbor the water often will become as smooth as glass. The boat in this drawing is in water that has very few ripples. Many mistakes are made in thinking that reflections are a reverse of the object. Notice in the drawing that the reflection is not simply a tracing of the boat turned upside-down. You are looking down at the boat, but in the reflection you are looking up. For example, you can see the top of the cabin, but in the reflection you see underneath the roof of the cabin. Water is drawn with horizontal strokes to achieve a flatness and perspective. You can become confused with so many rules about reflections; however, a few basic observations should be noted.

In A., you see why the reflection of a pole that is straight in the water should be at least as long as the pole itself. If the pole is leaning toward you, B., the reflection will be much longer than the pole appears to you, and if the pole is leaning away from you, C., the reflection will be shorter than the pole. I use a pole as an example, but this applies as well to the side of a boat, a tree, a house, or any object reflected. In D., notice how the reflection leans to the same side as the pole leans. If the pole leans to the left, the reflection will lean, from where the pole goes into the water, to the left. All verticals will reflect straight down, no matter how many there are or how wide apart.

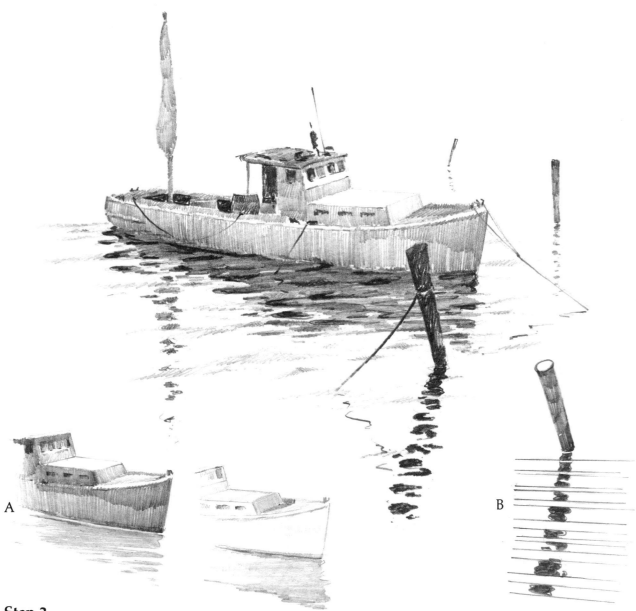

Step 2.

As the surface of the water becomes broken by the wind or a moving object, it distorts the mirror-like reflection.

A. How dark or light the reflection is depends upon where the sun is hitting the object. If the side of the boat is in shadow and the sun is hitting the top of the water, the reflection will be lighter than the boat. If the sun is hitting the side of the boat, how-

ever, the reflection will be darker than the side.

B. When the water is disturbed, it makes a series of hills and valleys. The sky is reflected in the raised portions and the object is reflected in the hollows. This breaks up the solid form and makes the reflection longer.

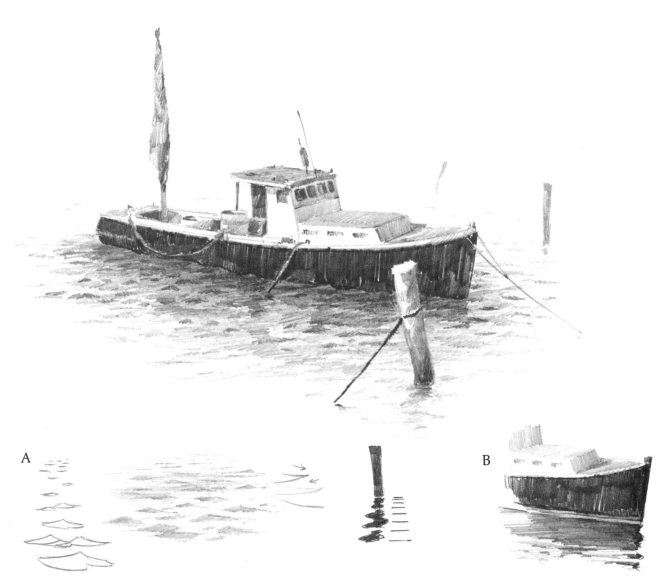

A.

B.

Step 3.
When the wind causes the water to break up into many small ripples, the reflection is lost. There is, however, a diffused area in the water under the boat.

A. Notice how perspective is involved in drawing water and reflections. The further the water goes away from you, the less distance between the ripples. The same rule applies where the reflections are more definite. The reflection near the base of an object is condensed, and it spreads out more and more as it comes toward you.

B. Most of the time the reflection of a black boat will be lighter than the boat itself. This is due primarily to the fact that no matter how dark the reflection, it will become lighter due to the transparency, the density, and the color of the water.

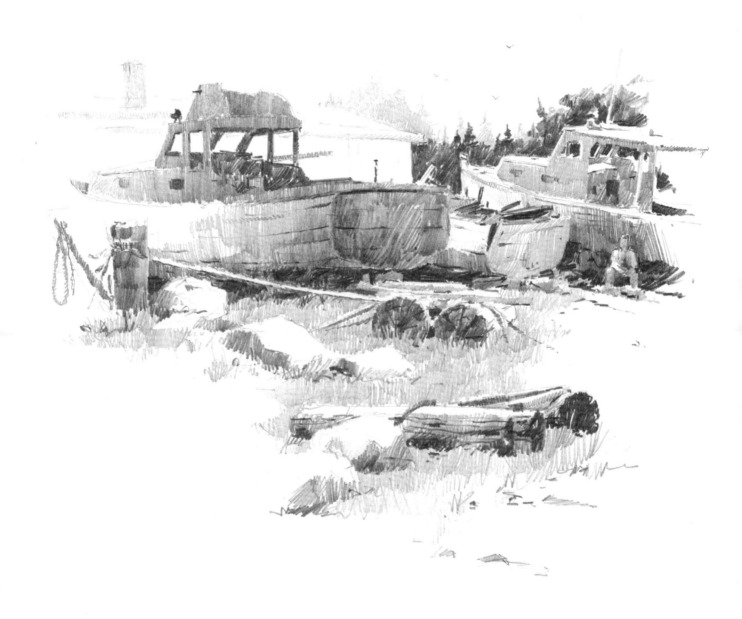

HERB MONTGOMERY'S BOATYARD

In this drawing I plan how I want the darks and lights placed, since the entire scene as it appeared was one value. I want an interesting play of lights against darks and darks against lights. After I lay-in the drawing with a 4H pencil, I make the background trees on the right my darkest value using 4B and HB pencils. Then, I draw the main boat dark, and make the building in the background light. This gives me the play of values that I am looking for. I indicate the foreground with a 2H pencil and a few accents with an HB pencil. The debris and logs make an interesting device to move the eye into the picture.

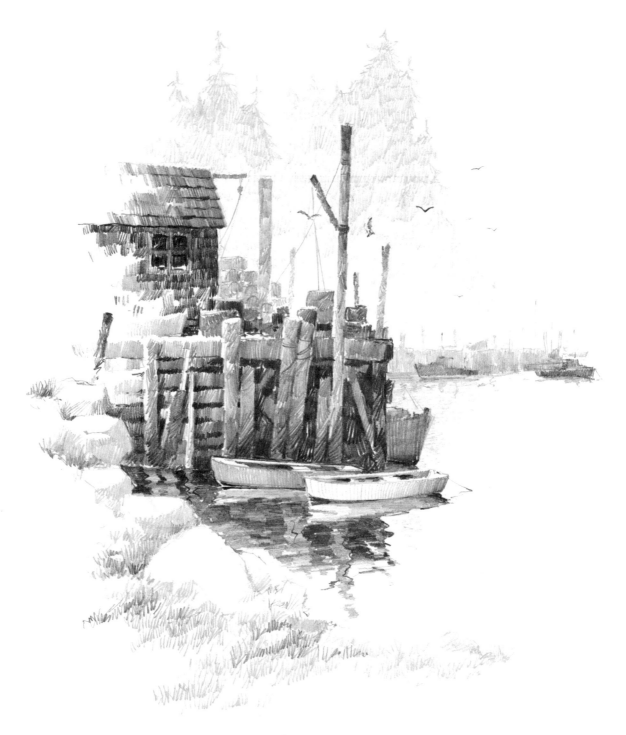

LONG COVE

This drawing is another case in which I have to make a change in the values as they appear. The background trees, the shack, water, and foreground grass are all dark. I want most of the interest in the foreground and in the shack, so I make the background a very light value with a 6H pencil. There is very little detail in this area so that it becomes a light silhouette. I then put in the shack and boats with 2H and HB pencils. I can put as much detail in this area without worrying about the value becoming too dark. The grass in the foreground and the water reflections are drawn to make an interesting vignette.

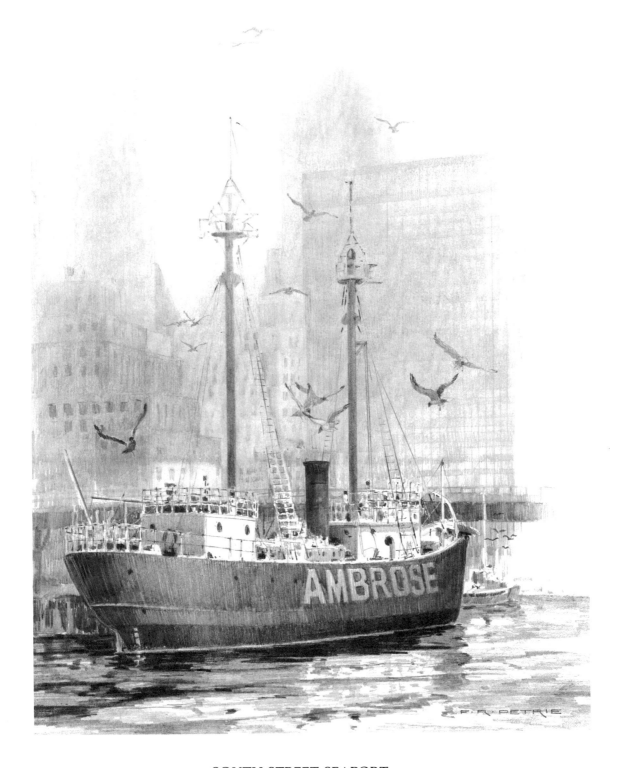

SOUTH STREET SEAPORT

Early one morning I drew the Ambrose Lightship, accompanied by about 150 cats who were inquisitive observers. Next to the Ambrose there was a long pier, where I was able to draw this view of the ship. I took considerably longer to do this drawing because I was interested in the accuracy of the detail in the ship and the buildings in the background.

I make a careful lay-in drawing with a 4H pencil and render the complete background with a 2H pencil. After these tones are laid in, I smudge the entire area with my finger, obtaining very soft edges and a hazy effect. I draw the ship next with 2H and HB pencils. I add the darks in the hull and water with a 2B pencil. With a 2H pencil, I carefully place the gulls to give action and movement.

Drawings and Photographs

On-the-spot drawing, like on-the-spot painting, is a challenge to the artist. The simplification, selection, rearrangement, and interpretation of the area before you start, and what you actually put down on canvas or paper, are very different from sitting in a nice, comfortable studio and working from photographs.

Not only is the actual drawing difficult to do on-the-spot, but it can be a problem having people constantly looking over your shoulder asking questions. I can recall in my student days in New York City, the class went out painting in one of the business intersections. Most of us tried to find a small corner where no one would annoy us. However, the class jokester set up his easel in the middle of the street, so cars had to go around him. He completely blocked out anybody or anything that was around him. The fact that the police came and took him away did not alter the fact that nothing bothered him when he was painting.

It is not quite so easy for me to ignore people and the questions they ask. Keep in mind, however, that if you are self-conscious about working in front of strangers, you are probably much better than any of them at drawing. It is always amazing how friendly and polite people can be as they watch you draw. Whenever I feel pleased with what I'm drawing, along comes a boy of six or seven who says, "My little sister can draw better than that!" Or, probably the most frequently asked question is, "Are you an artist?"

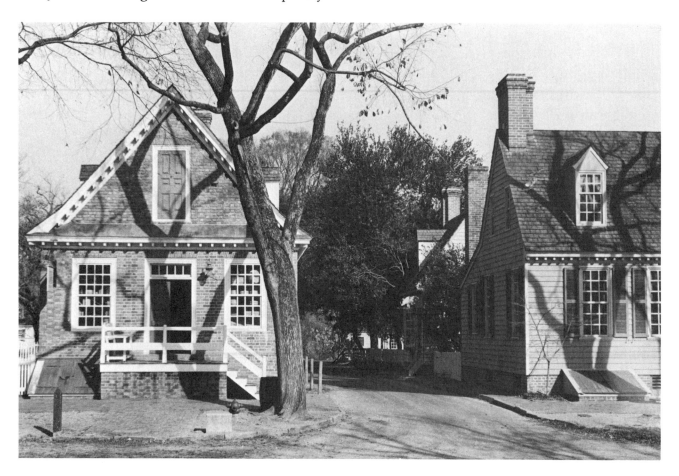

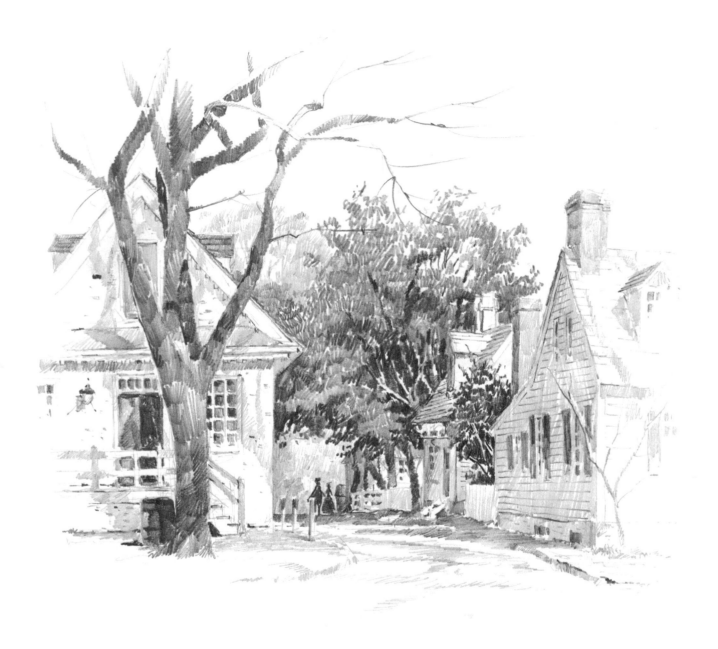

Down Colonial Street

I change very little in this drawing as you can see from the photograph. I feel the four major elements—the two houses, the foreground tree, and the trees in the background—all form a good composition. The trees in the background form a nice arch to connect the two houses and hold the drawing together.

There are several areas I do alter, however. I move the tree to the left, so it will not block the corner of the house. I feel the corner is a very important structural part of the house. I also lighten the value of the house on the left because I want a strong contrast between the tree and the house. The rest of the values are kept pretty close to the values in the photo. The only area I do lighten is at the end of the street, since it presents a good opportunity to have a few figures silhouetted against a light background. The angle of the road, fences, and houses, all lead to the figures.

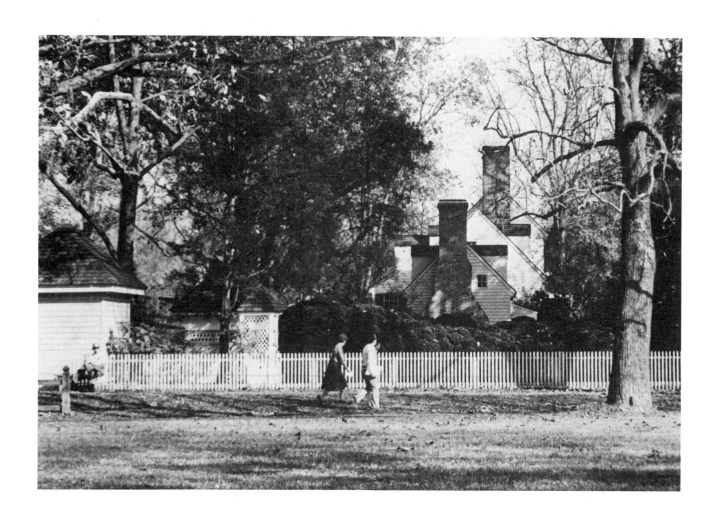

St. George Tucker House

I do very little changing on the house itself. The angles of the roofs and chimneys are so interesting I leave them as they are. The foreground and the background I do change considerably. I simplify the trees in the background, since I do not want them to become too dominant. In order to have a place for my eye to move into the picture, I open a gate in the fence. Also I feel the fence creates too much of a barrier. Since more darker tones are on the left, I decide to bring more interest to the right by moving the small building to that area.

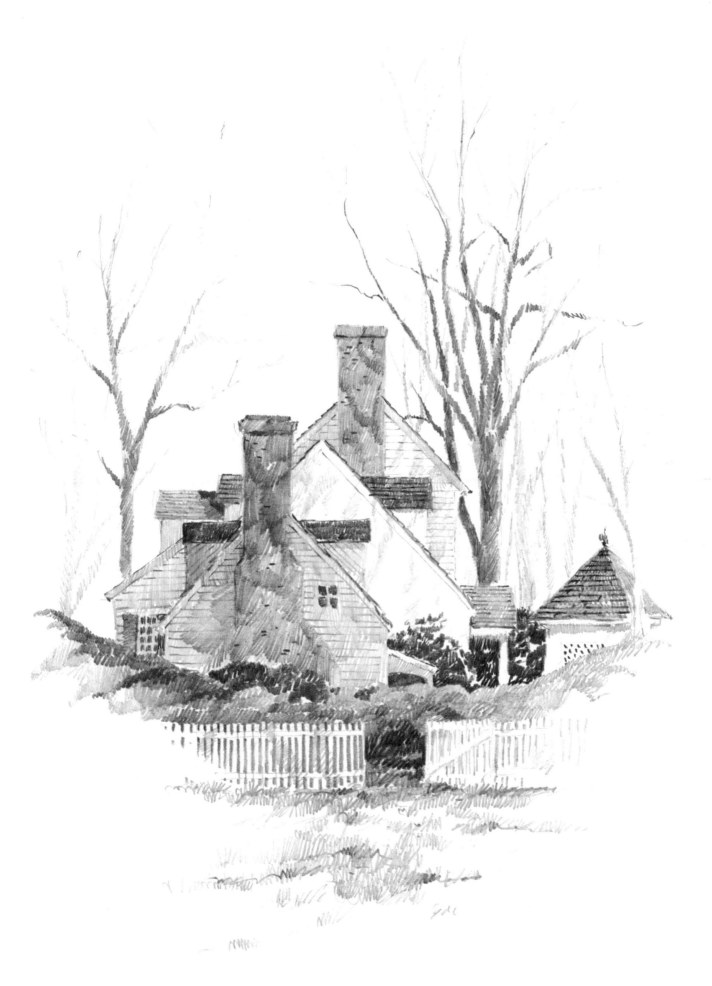

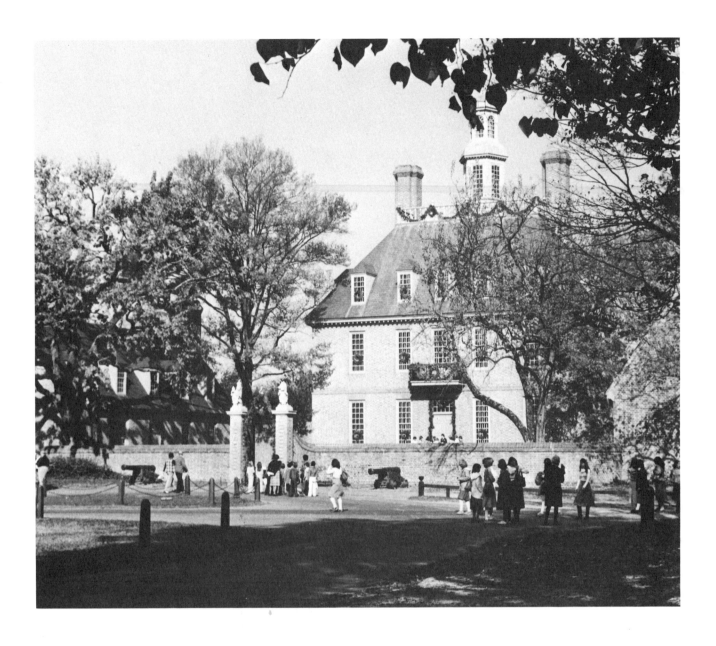

The Governor's Palace

Very few changes are made in this drawing. I move the main tree away from the left post of the gate because it creates too much of a straight line. I also omit the posts and chains in front of the palace gates. I do not want to clutter the foreground with additional spots. I feel the road is a strong enough element to move the viewer's eye to the gate where I want it to focus. I decide against making the dark branches and leaves a frame for the upper part of the drawing. It will add a distracting area and take attention away from the gates.

Later, as I looked at the drawing in my studio, I felt I should have included a few figures in the foreground. At the time I did the drawing I left them out for the same reason I did not include the fence. However, it could have been an interesting touch.

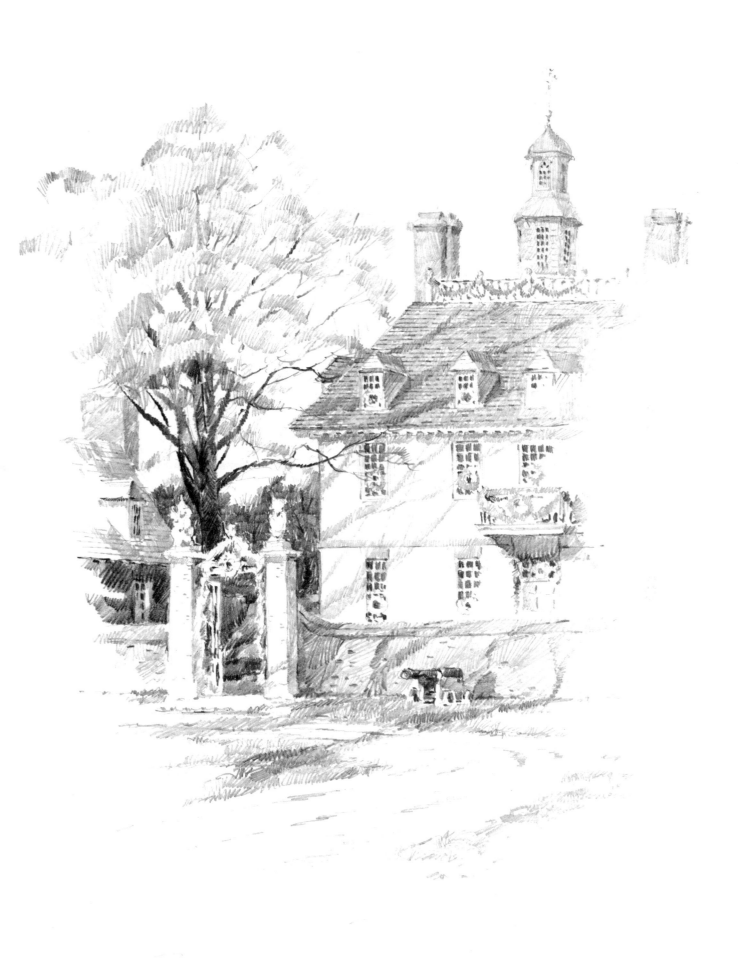

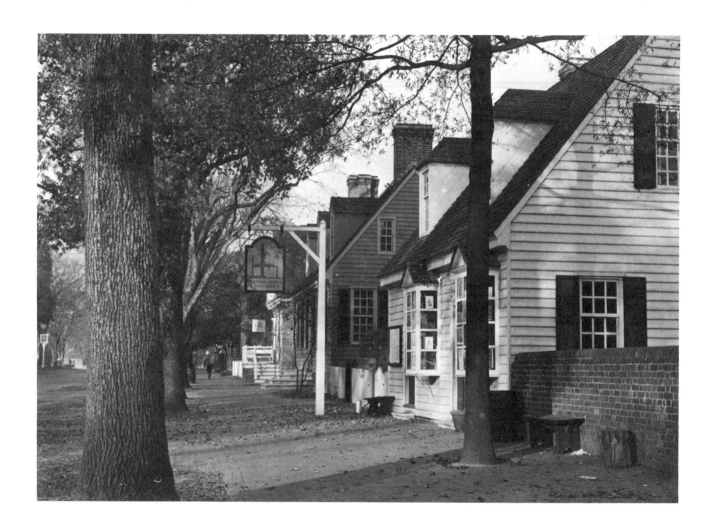

The Printing Office

I move the tree to the left so it will not block the windows of the main building. Many times the best view of a house has a tree in front of an important area like the front door or windows. I always move the trees rather than move the viewing point. I leave the large trees out on the left for a better vignette and add the small ones on the right for the same reason. Although it was not a cobblestone sidewalk, I was able to create more movement by indicating a few cobblestones leading into the picture.

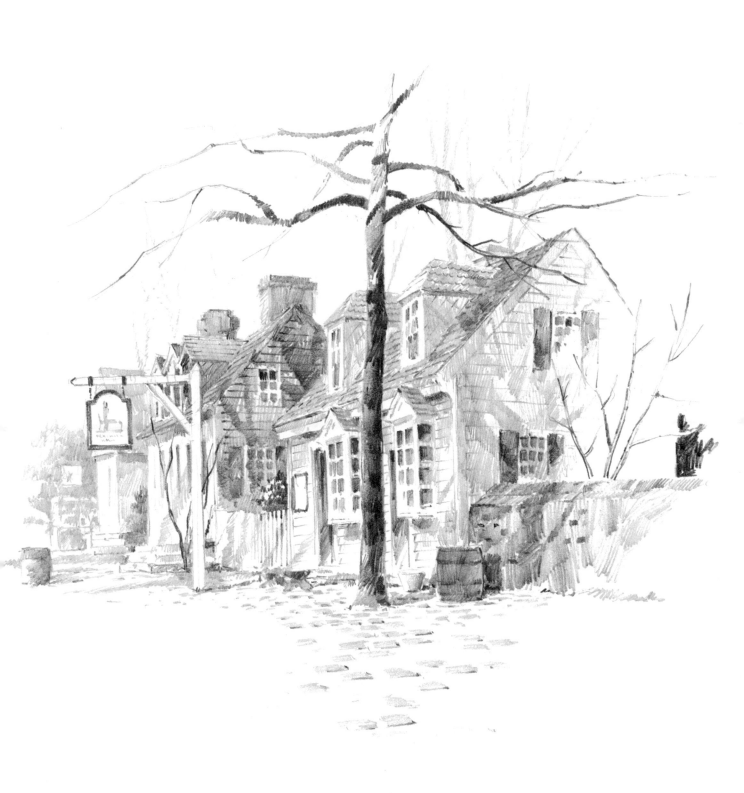

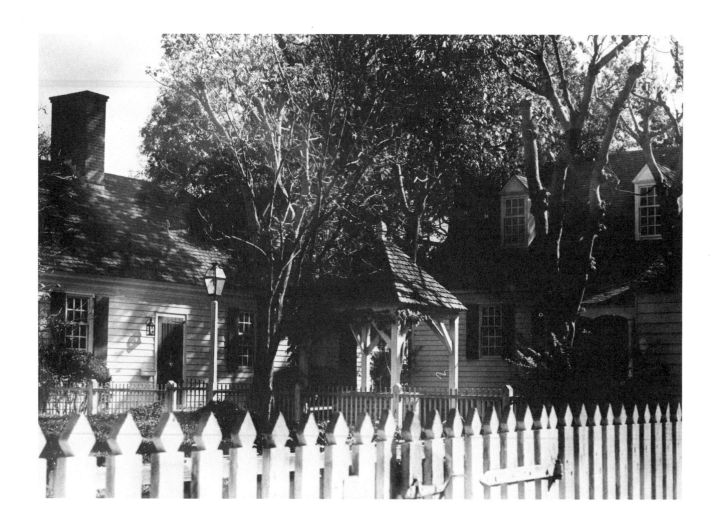

The Back Yards

There are so many shadows in this scene that the complete area becomes quite dark. I cannot wait for the sun to move around to give me proper lighting, so I change some of the values as I compose the picture. I feel the well on the right is important, so I keep the darks against the lower portion and fade off the house behind it. This whole area is a very dark value. To simplify the main tree, I keep the branches away from the well. I eliminate many of the shadows on the left house and add the small tree as a nice stopping point for the left side. I do not like the fence going all the way across the drawing, so I break it with shrubs.

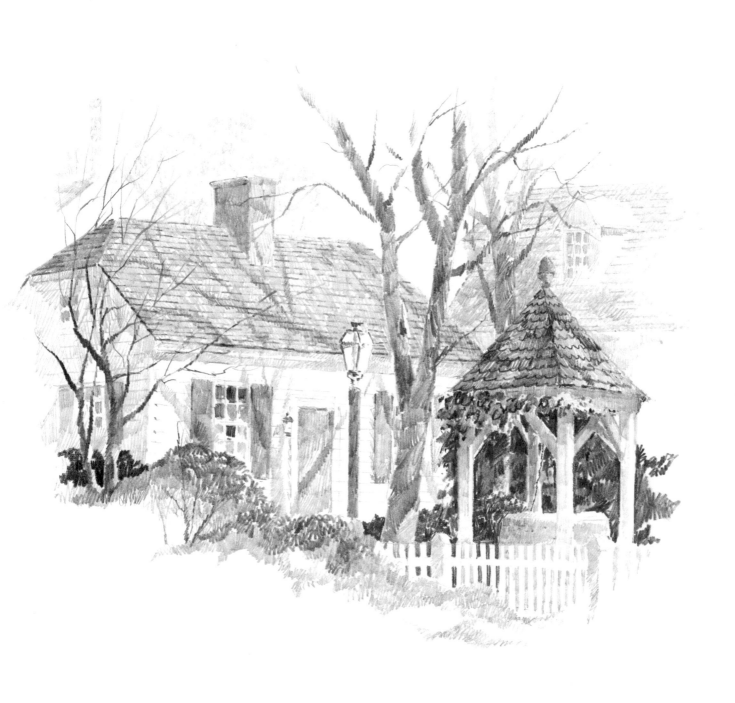

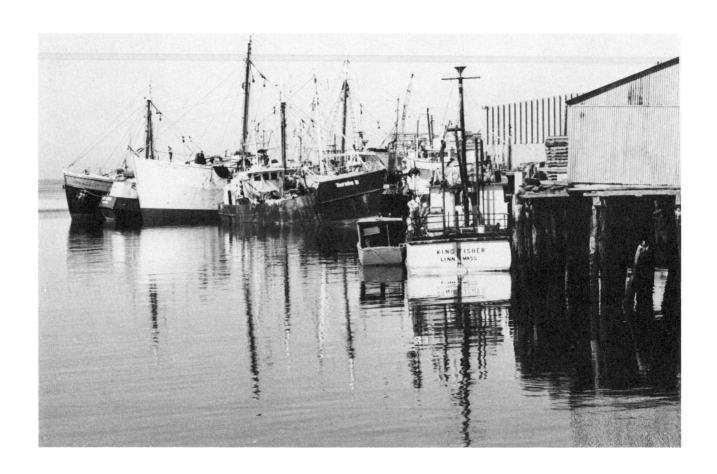

Gorton's Fish Pier

This is a case where there are just too many boats. With a maze of masts, hulls, lines, reflections, buildings, and fishermen, it is difficult to know where to start. I do realize right away, however, that I cannot include everything. So, I concentrate on the buildings on the right and the two small boats tied to it. The rest of the boats I fade, and I eliminate the last two on the left altogether. I use all of my darks in the foreground and leave out all the texture on the building for a better vignette. I simplify the reflections and give a simple treatment to the water. Since it was a very calm day, there was very little movement in the water. A scene like this can be overpowering if you try to include everything you see. Put all of your effort into a small area and make that as interesting as you can.

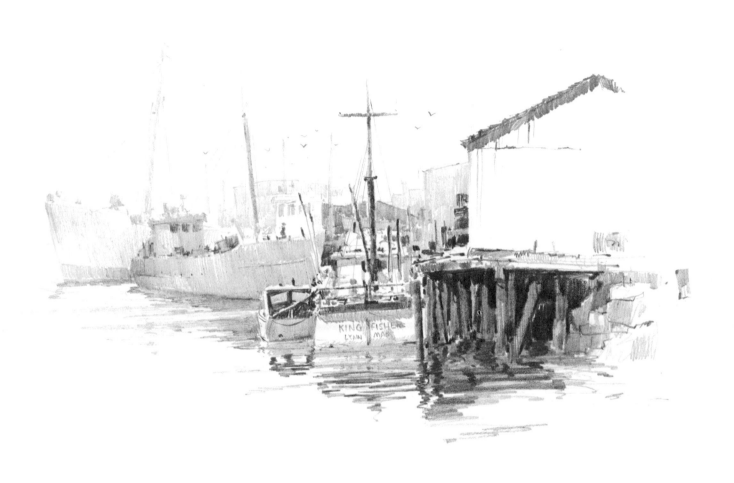

Rocky Neck

In this drawing I have a problem with the sun. The only position I can take to make the drawing is to look directly into the sun, which makes the larger boat, the reflections, and the pier area very dark. I decide to maintain that effect, so I keep my dark values in the same pattern. By making the distant shore very light in value, I will not interfere with the silhouette of the boats. An additional element is introduced with the dock and the boat in the foreground. Because the complete dock and the boat are too far from the larger boats, I shorten the floating dock. This makes a better composition since it brings all the elements together.

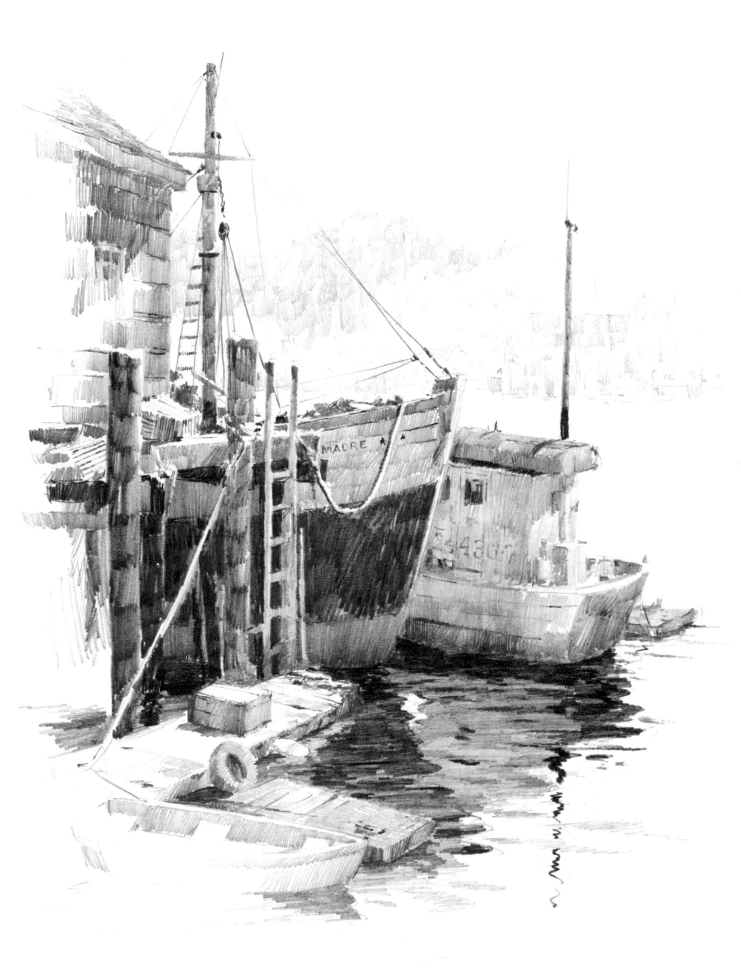

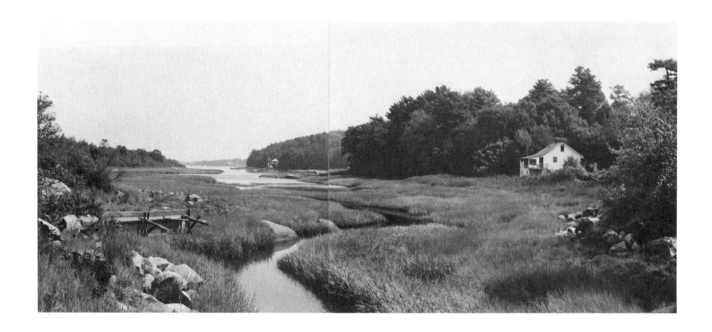

Quiet Inlet

Salt marshes and meadowlands make interesting subjects for drawings and paintings. The flatness of the land and the water snaking through the grass make it easy to move the viewer's eye back into the picture. Although long pictures are interesting, I feel there is too much area of no interest. I therefore move the house on the right into the picture, eliminating most of the large tree bank. To make the wa- ter the center of interest, I shorten the left side also. This is a good example of aerial perspective. I make the tree bank furthest away an eighth value, and as the trees come closer I darken the value. The house on the right becomes important because of the strong contrast between the light house and the dark trees behind it.

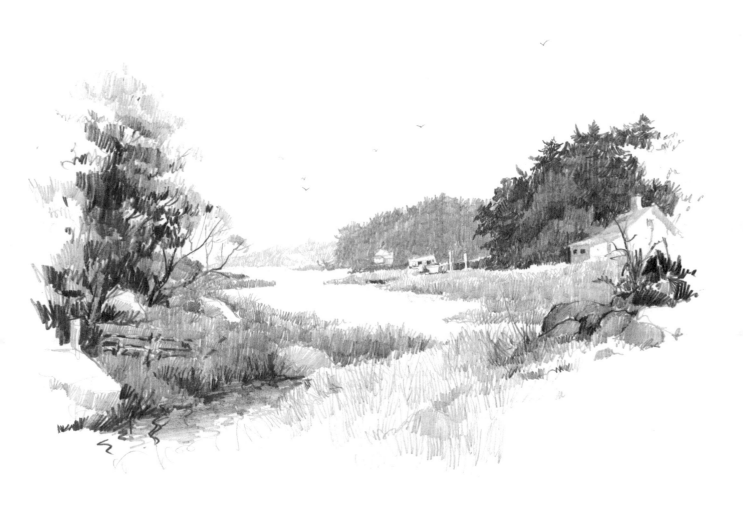

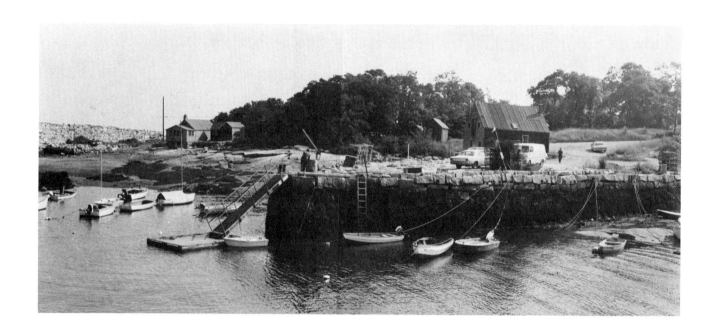

Lane's Cove

In this drawing, I have to decide what I want as my center of interest. The long flat rocks with the boats and houses make an interesting subject. The floating dock and stone pier I feel are important, and the large shack and trees in the background are good subject matter. Care has to be taken because there are actually three drawings that could be made of one subject.

Finally, I decide to make the end of the fishing pier my center of interest. To do this, I subdue all of the elements around it. I lighten the complete area, drawing enough detail in order to see what is going on. This makes the end of the stone pier become a silhouette. I keep the shack dark in value, but move it closer to the end of the pier so it becomes a unit. Since I do not want to draw all the boats, I leave only enough to create the feeling of an active harbor. Adding more boats would make them become too prominent.

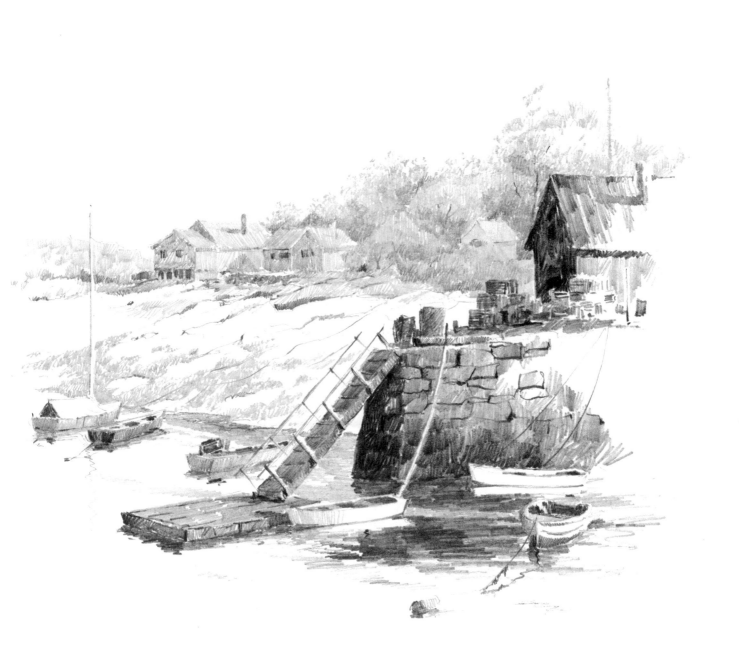

Along Nicholson Street

Here is an example of a very confusing scene. Too many trees create a diversion that cuts the scene in sections. I therefore eliminate most of the trees along the road so I will not cut the drawing in half. In the background, I leave a few trees around the house. Rather than leave the road flat, I feel it will look more interesting if it is going over a hill. I want to move the viewer's eye into the picture, so I leave the posts along the road. The posts and the fence give me the movement in the foreground I am looking for. An interesting perspective problem results: the house on the right is below my eye level, while the rest of the drawing is eye level or above. I minimize this area, since I decide it will look too confusing.

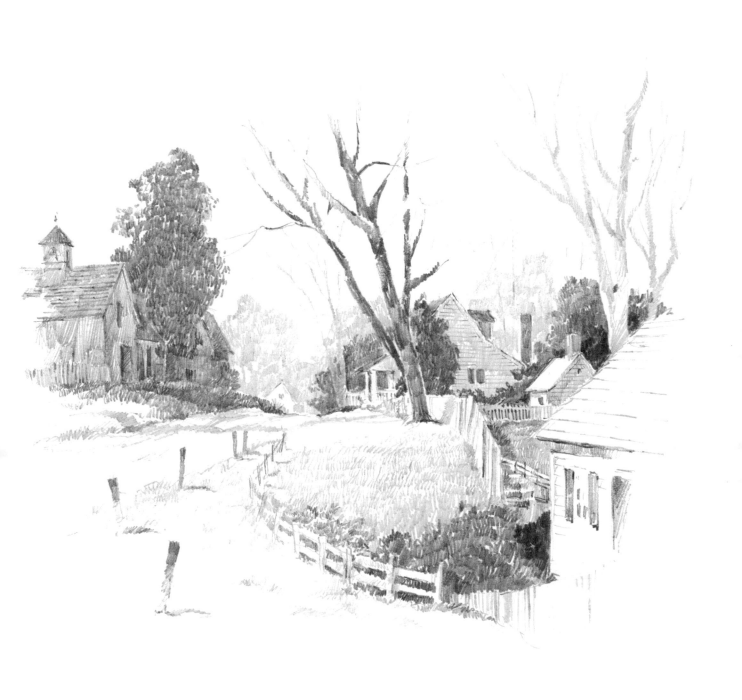

Matting and Framing

It is a true saying that good matting and framing do not necessarily make a good picture. I have seen a poor painting presented in a beautiful frame and it does not make the painting any better. A beautiful drawing or painting, however, deserves to be presented in the best possible manner. If a good frame does not make a good picture, the reverse is also true: Poor framing can ruin a good picture. I have seen paintings and drawings that have taken considerable time and effort to execute, but were cheaply and poorly framed.

In this chapter I want to cover several methods of matting and framing your drawings.

Selecting the Type of Mat

Mat boards come in various colors, surface textures, and thicknesses. Since no color is used in pencil drawing, the color of the mat is not as critical as in framing paintings. When not using white, I prefer the grayed, pastel colors, such as olive green, gray blue, or gray. Occasionally, I have used bright colors like red or yellow. The color of the mat depends on where the drawing will be hung and your own personal preference.

Surface textures include fabric mats, where a fabric is glued onto a board, pebble, matte, or smooth surface. As in selecting mat colors, the choice of texture is primarily an individual one. Except for the fabric boards, the surface is hardly noticeable when the drawing is framed.

A standard mat board is single or double thickness. The single mat is approximately 1/16″ (.16 cm) thick, and the double mat is ⅛″ (.32 cm) thick. (See Figures 28-34).

Cutting Mats

There are many excellent mat cutters on the market today, ranging from a simple mat knife for about $2.00 to elaborate machines over $300.00. The type you'll buy depends mainly on how often you must cut mats. All the automatic cutters come with a manual to explain exactly how to cut a mat.

I double-mat all my pictures with either a color for the outside mat and a white liner, or a light warm gray outside mat and a dark gray liner. The liner (or inner mat) is ¼″ (.64 cm) or ⅜″ (.95 cm) wide. The width of the mat depends upon the size of the picture. For a 12″ x 16″ (30.5 x 41 cm) picture I use a 2½″ (6.3 cm) mat, for an 18″ x 24″ (46 x 61 cm), a 3″ (8 cm) mat, and for larger pictures a 3½″-4″ (9-10.2 cm) mat. I prefer the bottom border slightly larger, for example, the side and top borders 3″ (8 cm) and the bottom border 3½″ (9 cm).

Selecting the Frames

Most of the frames I use around my drawings are small and very simple. The elaborate frames used for oil paintings seem inappropriate for drawings. Since I do not want to detract from the drawing, I use small ½″ (1.3 cm) black, gold, silver, or plain wood molding (Figure 35).

Figure 27. Beveled Mat. *(Right) This is a simple white mat cut at a bevel (45-degree angle). Although a bevel on the inside is not necessary, it looks more professional.*

Figure 28. Double Mat. *(Far right) This is an example of a double mat. The inside mat is usually ¼″ (.64 cm) to ⅜″ (.95 cm) smaller than the outside mat. The inside mat is called the insert.*

Figure 29. Double Mat with Color and Insert. *(Far left)* This is a double mat with a color or toned mat on the outside and a white insert.

Figure 30. Double Mat with Toned Mat and Insert. *(Center)* This double mat has a toned mat on the outside and a darker tone for the insert. I prefer this for most of my drawings.

Figure 31. Border Variations. *(Left)* The borders do not have to be the same all around. In this example, the sides are narrow, the top is a little wider, and the bottom is the widest.

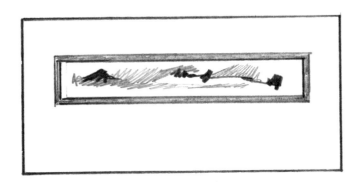

Figure 32. Mat Variations. *(Left) Extra long or odd shaped drawings take a little imagination in matting. Many times a very wide bottom margin is effective in unusual shaped pictures.*

Figure 33. French Mat. *(Above) This is called a French mat. It is a double mat with several thin lines in the margin area. They can be drawn with a pencil, ink, black or color lines, or tape.*

Figure 34. Using the Right Frame. *(Right) I find that a simple black, gold, or wooden frame, double-matted, makes the neatest presentation of a drawing.*

Portfolio of Drawings

In this final chapter I include some examples of drawings. They were all done on-the-spot and drawn the same size as reproduced, except where the size is indicated. Keep in mind, also, that the preparation, planning, and techniques are the same as I have explained throughout this book.

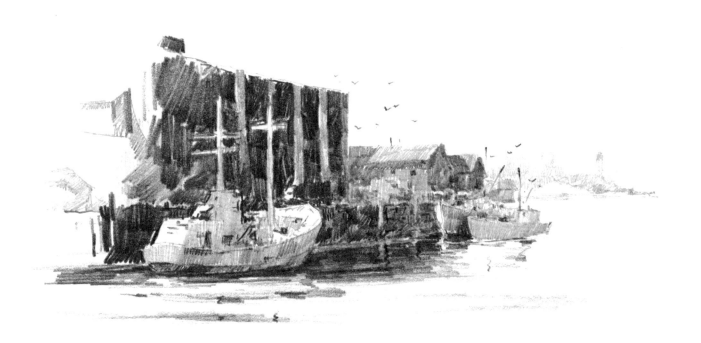

5 POUND ISLAND

After finishing the drawing of Gorton's Fish Pier, I looked to the left and saw a beautiful contrast of light fishing boats against a dark building. This is more of a value study than it is a finished drawing, since I am only interested in the strong contrast. With this area as my light and dark values, I add the island and lighthouse using a light middle tone as a balance. Using a 2B pencil, I draw the dark building and pier, then use a 2H pencil for the smaller building, and a 6H pencil for the island in the distance.

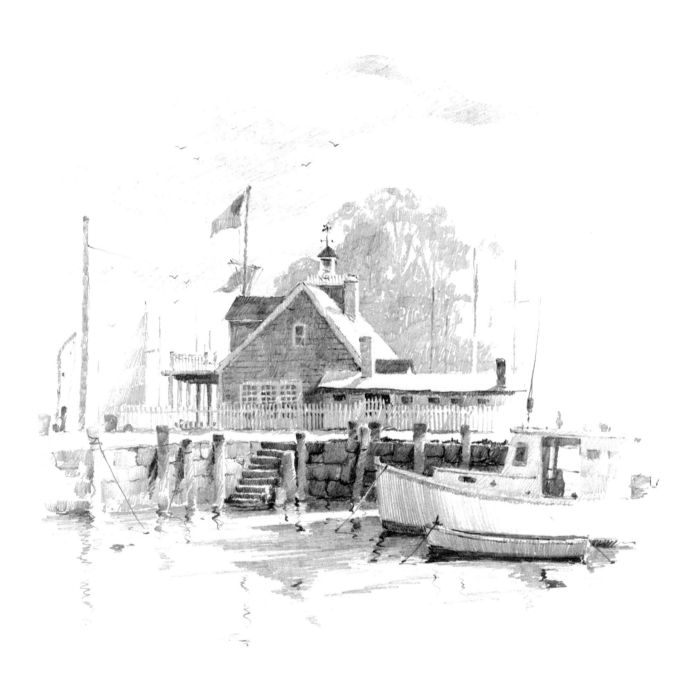

THE YACHT CLUB

This is an example of horizontal and vertical movement. The verticals of the masts, porch, fence, and pier posts all render a very strong feeling of a vertical movement. To counter this movement, I emphasize the horizontal of the roof, the top of the pier, and the water. Rather than have the boats at an angle, I also leave them as a flat horizontal thrust. I keep most of my darks in the pier, so I get a sharp silhouette of the bows of the boats. The softness of the background trees adds a contrast to the sharp angles of the rest of the picture. The darks in the foreground are drawn with 2B and HB pencils, the building with a 2H pencil, and the background trees with a 6H pencil.

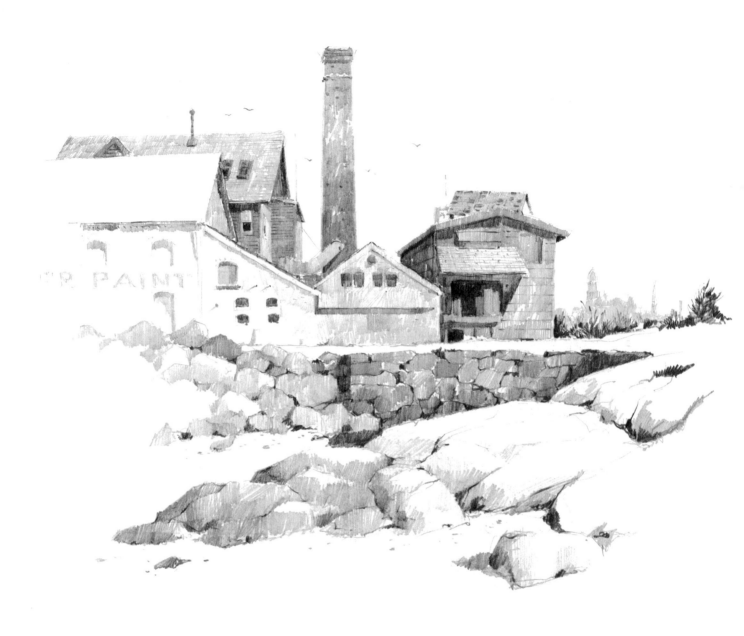

GLOUCESTER PAINT COMPANY

Here is a nice opportunity to create an interesting vignette with the outline of the factory and the foreground rocks. I center most of the texture and tones in the building on the right, and the smokestack and the background building on the left. By doing this I am able to move the viewer's eye from the lower left to the wall on the right, then to the building on the right, and then to the left. This eye movement is done, not by the placement of elements, but by the careful placement of values. I indicate the windows in the building on the left, and I leave a lot of white in that whole area. The foreground rocks are drawn with a 2H pencil and for accents an HB, and the background buildings with HB and 2B pencils. I pull all the tones together by going over the toned areas with a 6H pencil.

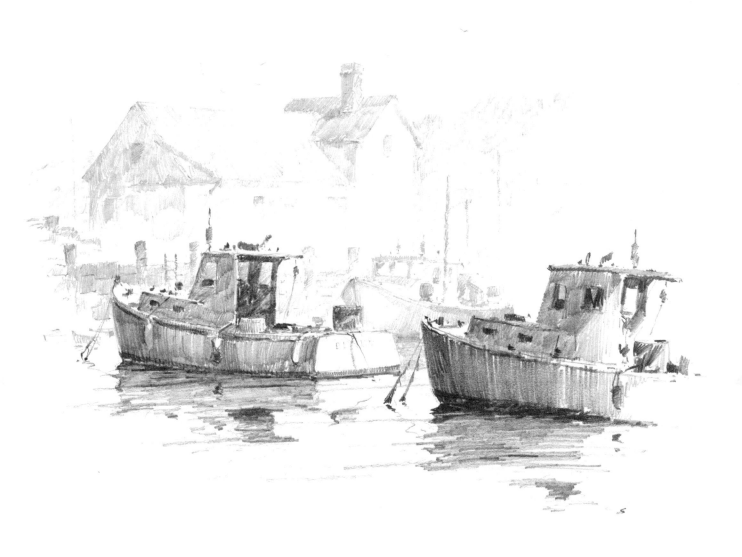

MOTIF #1, ROCKPORT, MASSACHUSETTS

Although the fishing shack, which is called Motif #1, is the important area, I purposely subdue it so that it will be a background for the boats. By having the boats facing left, the viewer's eye starts at the right, follows the boats, and is brought back into the picture by the dock and the Motif. The darker values in the boats are drawn with 2B and HB pencils and the lighter tones in the boats with a 2H pencil. I indicate the background area with 6H and 4H pencils.

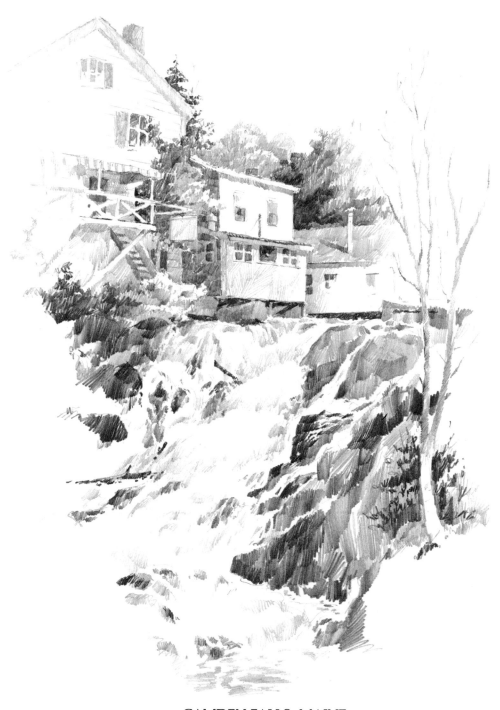

CAMDEN FALLS, MAINE

In this drawing everything in landscape drawing is involved—houses, trees, water, and rocks. Although the houses and trees are only background areas to the waterfall, they are still important frames for the water. I keep most of my light values in the falls with a few small rocks breaking up this area. The foliage and trees are drawn with a 2B and an HB pencil. I indicate the rocks with 2H and HB pencils using strokes that follow the angles of the rocks. To draw the water, I use a 6H and a 4H pencil and for the small accents a 2H pencil.

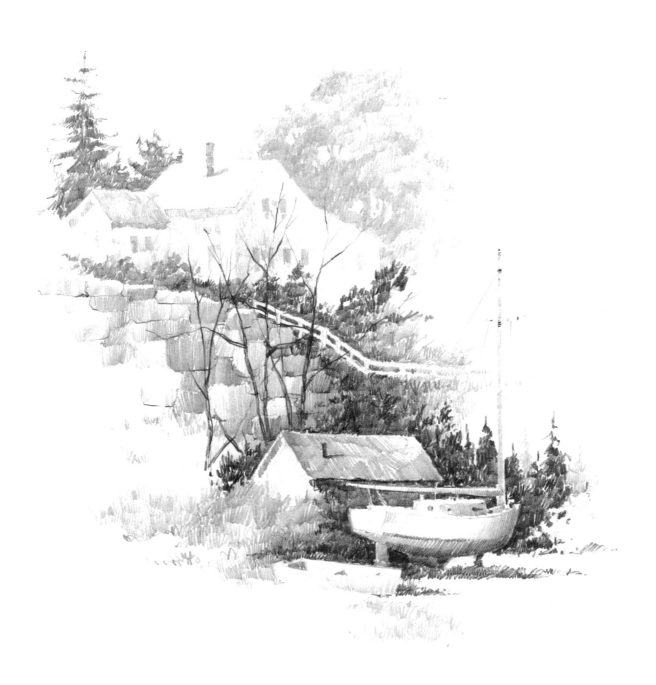

GRANITE PIER

At first I thought there were too many subjects here to make a good composition. When I have two or three competing elements, I like to make one more dominant than the others. In this case, however, the boat and shack, the stone wall, and the house in the background are all approximately the same size. I therefore decide to put the emphasis with my darks in the foreground area and subdue the house. I further emphasize this by making the trees overlap the house. To connect the foreground with the background, I use the fence and dark trees. The darks are drawn in with HB and 2B pencils and all the light tones with 2H and 4H pencils.

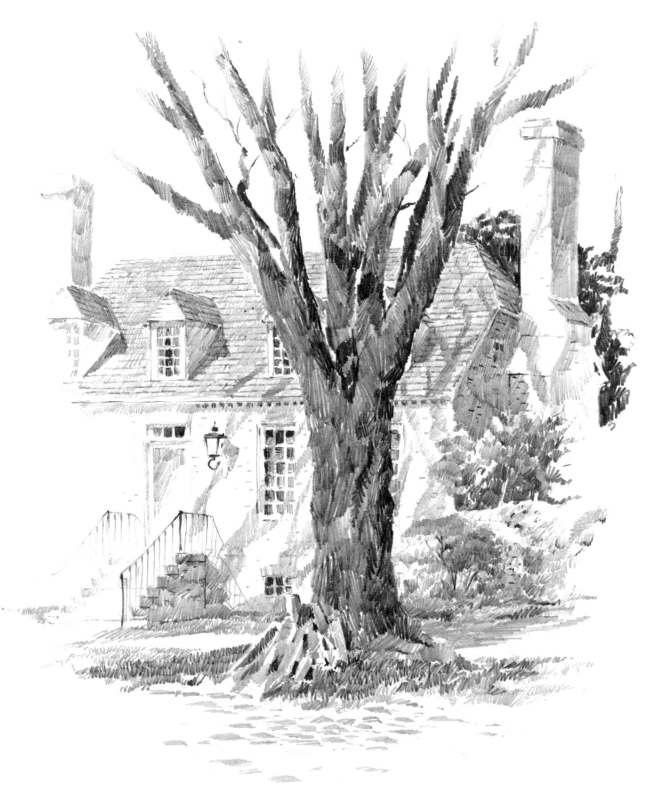

THE COLONIAL HOME

In this drawing, I thought the difference in value and texture between the old tree in the foreground and the house in the background would make an interesting comparison. I place all the darks in the tree, so that it will stand out against the house. Many times, if the background area has darks in it, the drawing will become confusing. For example, if I had made the roof area, or the windows next to the tree trunk as dark as the tree, it would have made a very confusing silhouette. Although there is a great deal of detail in the house, it stays in the background because of the light tones. In the tree I use HB and 2B pencils and for the house 2H, 4H, and 6H pencils.

ALONG THE DUKE OF GLOUCESTER STREET

This scene is similar to the Colonial Home drawing. In this drawing, however, I move back from the house so that the tree becomes a part of the background picture instead of the foreground center of interest. I spot additional darks around the front of the center house, so that it will stand out. I put the dark tree in the area where I feel the shadow falling across the front of the center house will give me a strong light direction and add a bit of interest. The bricks in the foreground lead the viewer's eye into the picture. All the dark areas are put in with an HB pencil and spotted with a 2B pencil. The middle tones with 2H and 4H pencils and the background trees with a 6H pencil.

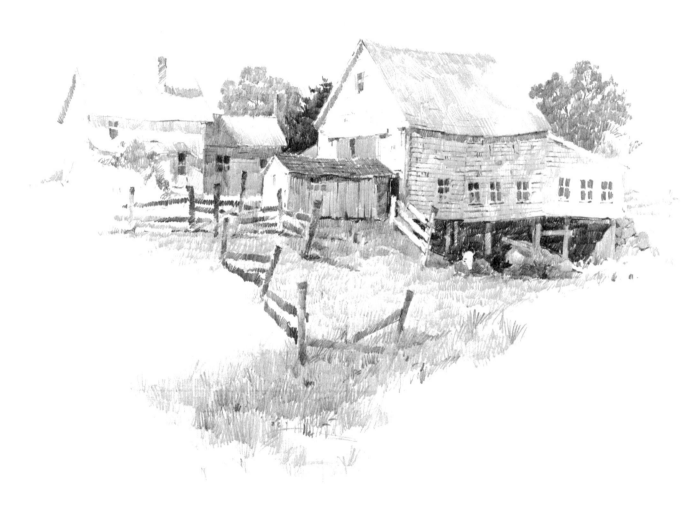

FARM COUNTRY

The angle of the fence in the foreground makes a natural movement for the viewer's eye into the picture. The beauty of these old barns is in their various textural patterns. I therefore spend a considerable amount of time on rendering the house and barns. Most of my darks are centered under the large barn to give me a feeling of depth in that area. The darks are done with a 2B pencil and the middle tones in the barn with 2H and 4H pencils.

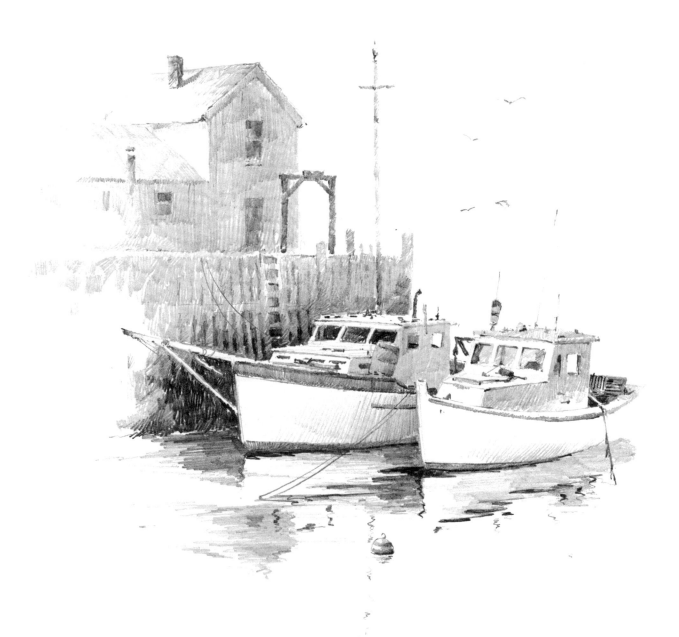

SIDE BY SIDE

What interests me here is the two boats in the foreground and the sharp reflections they make. I make the area very dark around the bow of the left boat to give a sharp silhouette and to enhance the feeling of light hitting the boats. When drawing two boats like this, be sure to leave enough room between them so that one isn't sitting on top of the other. Since the water is still, the reflections are sharp. I draw the background area using a minimum amount of detail and values. I add the gulls to balance that open area and to give a little action to the drawing. For the darks around the boat, I use a 2B pencil and for the remainder of the boats and reflections I use 2H and HB pencils. The background shack is drawn with 4H and 6H pencils.

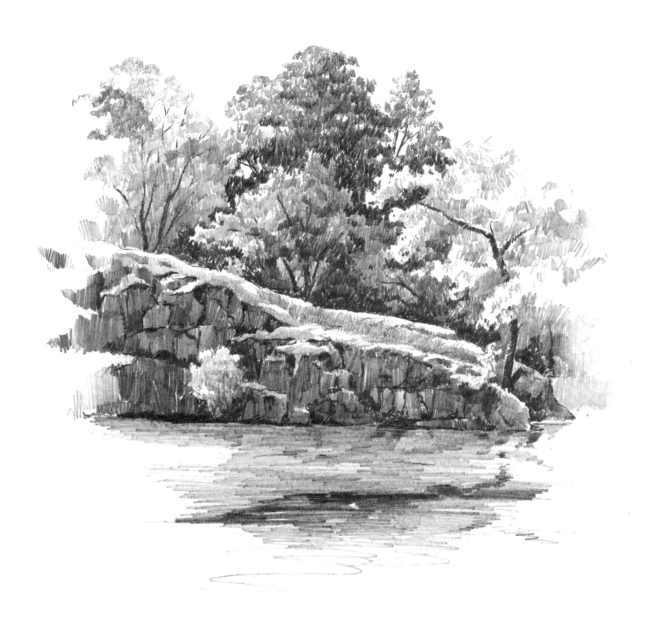

THE WATERING HOLE

Here, I am interested in comparing the softness of the trees to the hard edges of the rocks. This drawing is primarily a matter of textural treatment of these two areas. The rocks are rendered with vertical strokes following the form using an HB pencil, and for the accents a 2B pencil. I vary the values in the trees to create more interest. They are drawn with HB, 2H, and 4H pencils. I indicate the water with horizontal strokes. By adding the dark area in the foreground, I give a little direction to the viewer's eye. The water is drawn with a 2H pencil and the darker area with an HB pencil.

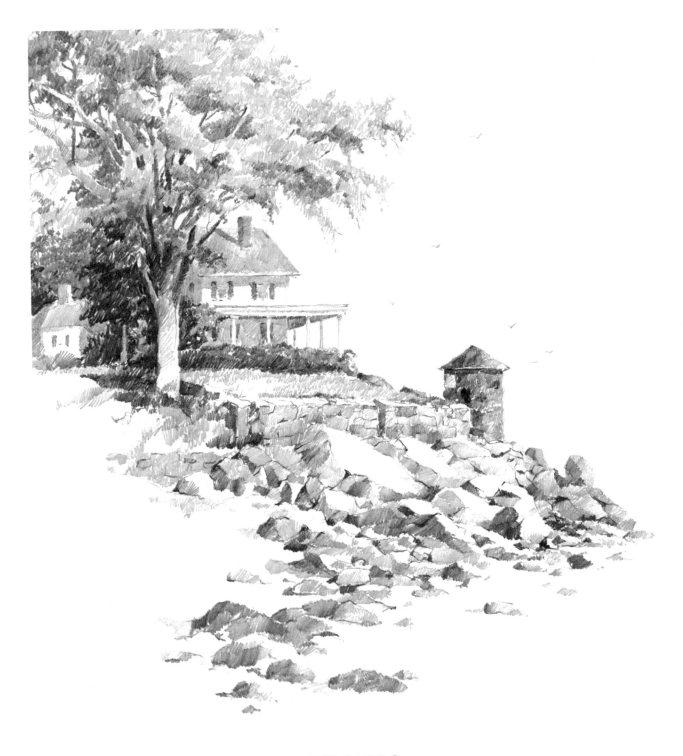

THE GAZEBO

First, I decide to square-off the top and left edge. The large dark trees that frame the house are difficult to vignette, but they make an excellent background for the house. After I lay-in the picture with a 4H pencil, I draw the dark trees first using a 2B pencil. The gazebo and the rocks become my middle tones, and I draw these using a 2H pencil and the spots of dark with an HB pencil. I have to rearrange carefully the rocks in the foreground to create an S-shaped composition. This will move the viewer's eye from the lower left and lead the eye to the trees.

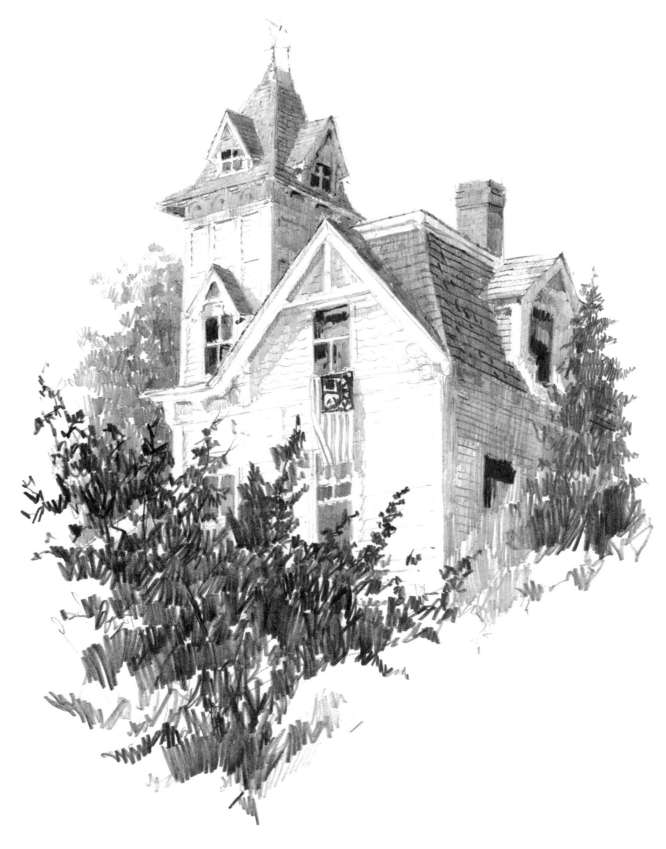

HOUSE ON PLEASANT STREET

Old Victorian houses are extremely difficult to draw because of the many angles, textures, and "gingerbread." With a 4H pencil, I make a careful lay-in drawing, which is a very important part of this type of drawing. Before any tones are indicated, the lay-in must be accurate. Once this is established, I indicate the shadow side of the roof and house with 2H and HB pencils. The darks in the windows and trees are rendered with a 2B pencil.

Index

Italicized names and numbers indicate illustrations

Ferdinand Petrie was born in Rutherford, New Jersey, and received his art training at Parsons School of Design and The Famous Artist School of Illustration. He also studied painting with Frank Reilly at The Art Students League in New York. After working for 20 years in advertising agencies and studios in New York City, he began painting full time. For the past 20 years he has operated his own gallery in Rockport, Massachusetts. Petrie's work can be found in many public and private collections throughout the United States.

Mr. Petrie's other book published by Watson-Guptill is *The Big Book of Painting Nature in Watercolor*, with photographs by John Shaw.